2018

MW00997110

ITALIC *and* COPPERPLATE CALLIGRAPHY

The Basics and Beyond

ELEANOR WINTERS

DOVER PUBLICATIONS, INC.
MINEOLA, NEW YORK

For Leendert and the Kitchen Girls

———————————————

Bibliographical Note
Italic and Copperplate Calligraphy: The Basics and Beyond
is a new work, first published by
Dover Publications, Inc., in 2011.

International Standard Book Number
ISBN-13: 978-0-486-47749-7
ISBN-10: 0-486-47749-5

Book design by Jason Snyder

Manufactured in the United States by LSC Communications
47749504 2017
www.doverpublications.com

TABLE OF CONTENTS

Acknowledgments

I am very grateful to the following extraordinary calligraphers who most generously permitted me to publish their artwork: Pat Blair, Mike Kecseg, Alice Koeth, Caroline Paget Leake, Carole Maurer, Barry Morentz, Anna Pinto, Sheila Richter, Michael Sull, and Jeanyee Wong. I would also like to thank Lisa Weingarten for her very fine photography, and Kay Radcliffe, whose beautiful marbled paper was specially created for this book.

A great debt is owed to Jeanette Green, without whose advice and support this book would not have been started, and to John Grafton and Suzanne E. Johnson at Dover Publications who helped bring the project to fruition.

I am also indebted to John Golden and Laurent Raccah for technological advice and trouble-shooting, invaluable in these computer-driven times.

My gratitude also goes to the John Paul Getty Museum and to Dover Publications for granting permission to publish the historical examples reproduced herein.

And finally, I would like to thank Bob Cooperman, Caroline Paget Leake, Carrie Robbins, Julia Paterson, Kathryn Sartori, Kathy Wallace, Terry Moriber, Roberta Wetherbee, and, of course, Leendert, for ongoing support and encouragement during the (several) years that this book was in the works.

INTRODUCTION

During the last twenty-five years, the popularity of calligraphy has been growing steadily. Calligraphy has evolved from an esoteric art form to an everyday pursuit for artists, students, and interested amateurs. This gratifying, not to say meteoric, development is witnessed by the ever-growing number of classes, workshops, exhibitions, books, and calligraphy organizations. Just a few years ago, this was not the case. To many, calligraphy was a relatively unknown art, a footnote in the history of twentieth-century art education and, indeed, a word that was unfamiliar to a remarkable number of otherwise well-informed people. An often repeated anecdote concerns a student who sat through an entire two-hour introductory session of an Italic class, only to realize that he was in the wrong room; he'd registered for a class in upholstery!

As with other popular forms of art, there are many possible resources available for the beginner: classes, how-to books, lectures, and demonstrations. It seems that just about every adult-education program and community center offers classes entitled Introduction to Calligraphy, Beginning Italic, or Copperplate 1. Bookstores are well stocked with manuals and textbooks for these classes, as well as a number of calligraphy-as-art books, showing the work of contemporary calligraphic artists, as well as beautiful examples of writing and illuminating from the past. These art books serve as an inspiration to beginners and experienced calligraphers alike, but they generally don't give any step-by-step instructions.

And that is where *Italic and Copperplate Calligraphy* comes in. The purpose of this book is to begin where the others leave off, to answer the big questions: "What's next?" and "Where do I go from here?" These are the questions so often asked at the end of beginner classes, when students are familiar with the minuscule and capital letters, have been introduced to the concept of spacing, addressed an envelope or two, and have been given a glimpse of the principles of layout and design. The luckier students are offered an Italic 2 class, or perhaps an Intermediate Copperplate workshop, but the majority of neophyte calligraphers are left without direction or more advanced instruction.

Italic and Copperplate Calligraphy will attempt to provide the map for this uncharted territory. We have chosen the two most popular hands (calligraphic alphabets) as our area of focus.

As previously noted, Italic and Copperplate are the most common choices in introductory calligraphy classes, especially in the United States. (In the UK, Foundational is more often taught as a primary calligraphic hand, but this is less frequently the case in the U.S.)

Italic and Copperplate have many characteristics in common, but also differ in many important regards. It is their position in the educational hierarchy that brings them immediately to mind as the appropriate choices for an intermediate/advanced level book. In the following chapters, we will consider these similarities and differences. We will study Italic and Copperplate in both their shared principles and their individual characteristics.

Although this book is primarily aimed at the non-beginner, we are including a few chapters which cover the basics. These can serve as either an in-depth review for those familiar with Italic and/or Copperplate, or as an introduction for enthusiastic students who wish to start at the beginning and progress to more complicated ideas, exercises, and projects. Whatever your level of expertise may be, these chapters are worth a few minutes—and possibly a lot more than that—of your time.

And finally, this book may also serve as an interesting resource as well as a challenge to calligraphers who are adept at *either* Italic *or* Copperplate, but unfamiliar with the other alphabet. It is hoped that the dual focus of this book will help these calligraphers to learn the other style, by comparing and contrasting it with the one which they already know. We hope that whichever group you may fall into, beginner or intermediate in both Italic and Copperplate, or experienced with one of these alphabets but not the other, *Italic and Copperplate Calligraphy* will offer you a new approach to calligraphy as a living and evolving art form.

PART 1

The Basics

Italic AND Copperplate /
Italic OR Copperplate

Choosing between two beautiful and useful styles of calligraphy can be daunting. Before embarking on the study of calligraphy, beginners are frequently faced with exactly this choice. They may make their decisions by asking themselves some questions:

 1. Which style appeals to me more?

 2. Would Italic or Copperplate be more useful to me?

 3. Which class is being offered at a time that fits into my schedule?

If you are equally drawn to both alphabets, and scheduling is not a problem, another question may arise: Why not learn both?

There are good reasons both for and against studying the two scripts simultaneously. If you have no familiarity with either Italic or Copperplate, and especially if you have never used a calligraphy pen of any kind, it is probably preferable to make a choice. Why? Since the two alphabets are written with *very* different pens, achieving the motor control for each is, of necessity, a separate process that requires exercise and concentrated practice.

We say "probably preferable" rather than "absolutely essential" because, with a reasonable amount of effort (and quite a lot of practice time), learning two sets of motor skills is certainly not out of the question. But most of us are circumscribed by time limitations, so even with the best intentions and a fully focused mind, learning to use the tools for Italic and Copperplate simultaneously can be quite difficult.

We therefore recommend that you, the beginner, make a choice. But which to choose? Choose the hand that you prefer. Thinking about commercial uses for calligraphy and/or calligraphy-for-profit at this time is fairly pointless. We will discuss how to get rich doing calligraphy (just joking) later in this book, but for the moment, be advised: you will not be going into business as a calligrapher quite yet. So look at some examples of Italic and Copperplate and make a choice.

But having said that, we are certainly well aware that many of you have already had some experience with both Italic and Copperplate and we would like to suggest that you can use this

Italic abc ABC
Copperplate XYZ

book in two ways: to pursue one set of instructions and exercises to advance your skills in either alphabet, or to alternate between the two. By comparing the results of similar exercises with different alphabets, you will enjoy the startling contrasts that result.

Let's pause to define the two alphabets and put them into their historic context.

ITALIC

Italic calligraphy, also called Chancery Cursive, was the handwriting of the Renaissance. It made its first appearance in the early fifteenth century, and flourished during the sixteenth century. Italic was used primarily as a correspondence and business hand, an *informal* script that was written more quickly than the formal contemporary manuscript hands, such as Humanist Bookhand and the late Gothic scripts, which were used in documents, illuminated bibles, and other church books.

Early examples of Italic come from the Chancery office of the Vatican, hence the names Chancellaresca Formata (formal Chancery script) and Chancellaresca Corsiva (the informal, linked style of Italic), but quickly spread through Western Europe. Among the most famous examples that are available to modern calligraphers are the writing books (contemporary "how-to" books that taught how to write Italic) of three Italian masters: Ludovico degli Arrighi, Giovanniantonio Taglienti, and Giovanbattista Palatino. Each of these writing teachers published a text book on Italic writing with glorious examples of the script, showing simple lettering as well as some wonderfully flourished calligraphy.

Arrighi's book, *L'Operina*, has been translated into English and reproduced in facsimile with the pages beautifully hand-lettered, in a close approximation of Arrighi's style, by the twentieth century American calligrapher John Howard Benson.

There are many other examples of sixteenth century Italic available for the student to examine. It is interesting to compare these earlier forms of some of the letters with our contemporary Italic alphabet. It is important to realize that the Italic hand of the sixteenth century remains elegant and easily legible nearly 500 years later.

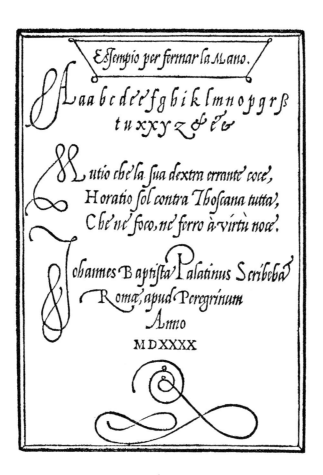

Palatino

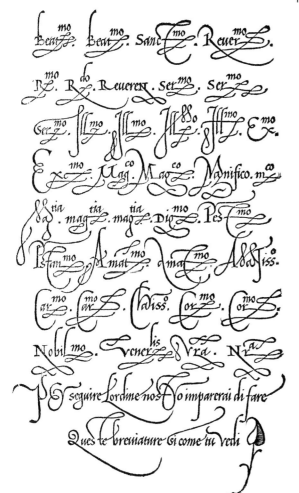

Tagliente

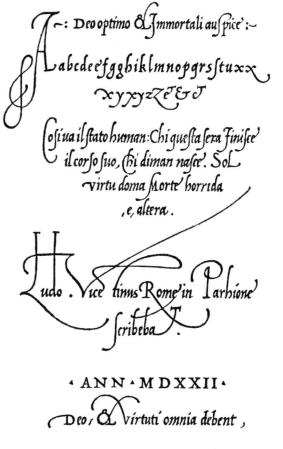

Arrighi

COPPERPLATE

Copperplate calligraphy, unlike other styles of writing, owes its name to a printing method, Copperplate engraving. The development of these letterforms, starting in the late seventeenth century and culminating with the English writing masters in the mid-eighteenth century (and indeed continuing well into the nineteenth century), were in effect a symbiosis between the shapes produced by the pen (or quill, actually) and the strokes that could be incised in a metal printing plate. In the hands of a master engraver, the hardness of the plate lent itself to curvilinear forms that were both rounder and more linear than the shapes of Italic letters, and the Copperplate alphabet developed a form, slant, and rhythm that has its own special character.

Various names have been given to this family of letterforms, the most common of which, to English speaking calligraphers, is either Copperplate or English Roundhand. A similar alphabet that developed in France in the seventeenth century is called Anglaise, but the forms we will be concentrating on in this book derive largely from the work of the English writing masters. Their artwork has been preserved for us in *The Universal Penman*, a compendium of extraordinary examples of penmanship dating from 1733 to 1743.

England's commercial preeminence during the eighteenth century called for a clear, legible, and rapidly written correspondence hand, and the clerks trained in Copperplate script were able to satisfy the demands of this flourishing business empire. Many of the examples of Copperplate that we study today were created by the writing teachers who were in lively competition with each other to attract students. We are fortunate to have examples of broadsheets (single pages of calligraphic prowess) as well as copy books to enable us to study Copperplate at its finest.

LETTERS.

By the Assistance of Letters the Memory of past Things is preserved, and the Foreknowledge of some Things to come is Revealed. By Them even Things Inanimate Instruct and Admonish Us.

ABOVE AND OPPOSITE:
George Bickham, The Universal Penman

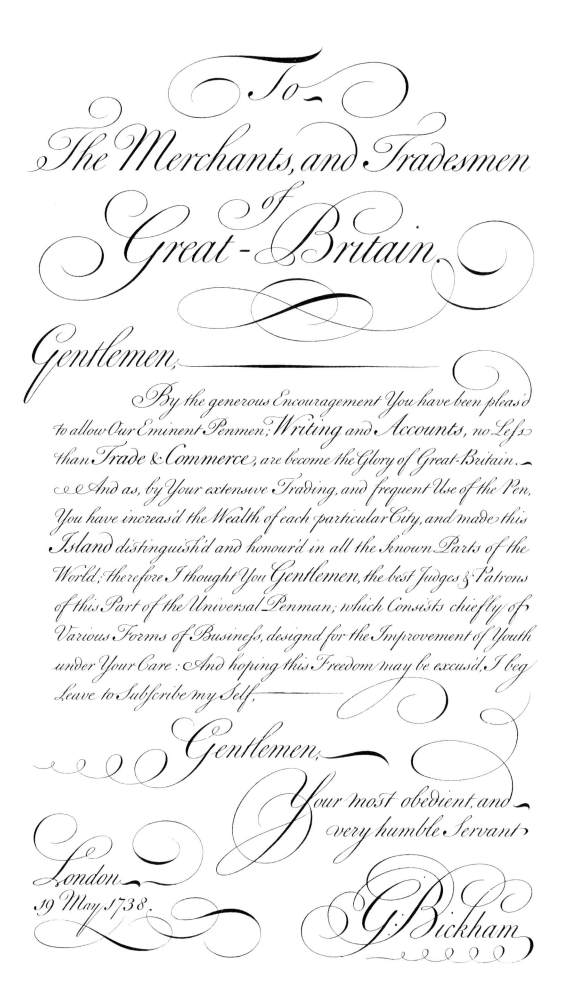

To
The Merchants, and Tradesmen
of
Great-Britain.

Gentlemen,

By the generous Encouragement You have been pleas'd
to allow Our Eminent Penmen; Writing and Accounts, no Less
than Trade & Commerce, are become the Glory of Great-Britain.
And as, by Your extensive Trading, and frequent Use of the Pen,
You have increas'd the Wealth of each particular City, and made this
Island distinguish'd and honour'd in all the known Parts of the
World; therefore I thought You Gentlemen, the best Judges & Patrons
of this Part of the Universal Penman; which Consists chiefly of
Various Forms of Business, design'd for the Improvement of Youth
under Your Care : And hoping this Freedom may be excus'd, I beg
Leave to Subscribe my Self,

Gentlemen,

Your most obedient, and
very humble Servant

London
19 May 1738.

G. Bickham

Tools & Materials, Light, Posture, Practice

Whether you are starting from scratch or reacquainting yourself with calligraphy, it's a good idea to read this chapter before you begin to write.

TOOLS & MATERIALS

The materials required for basic calligraphy are simple and inexpensive, but not always easy to locate. All you actually need to get started are pen, ink and paper, but it is necessary to determine which products are good and which are not. If you go into an art supply store and say, "I'd like to purchase calligraphy materials," you'll be very lucky to get any of the tools of the serious calligrapher, as opposed to hobby kits and packaged sets. It's always best to be armed with some specific information so that you can request exactly what you need. (Whether or not the shop will actually have what you need is another question. Mail-order calligraphy suppliers are often a better source of calligraphy materials than local art supply stores.)

The materials below are recommended for *both* Italic and Copperplate, followed by the nibs and penholders you will need specifically for each alphabet.

ITALIC AND COPPERPLATE

Ink You will need to use a *non-waterproof permanent* ink. Non-waterproof ink, as the name implies, will not run or smear if water touches the writing, or if you run a damp finger over a letter or line of calligraphy. Waterproof ink is impervious to most liquids, but it is rarely a good choice for calligraphy because it tends to be too thick and gummy to achieve fine line quality. Worse, waterproof ink will often cause deterioration of your nibs because these inks contain shellac or other corrosive substances.

A permanent ink is one that will not be affected by direct light. Writing done with a non-permanent ink will eventually fade if it is exposed to sunlight or strong artificial light; if you write with a permanent ink, this will not happen.

There are quite a number of inks available to calligraphers, but it is a good idea to read the small print on the package or in the catalog to determine that the ink is *both* non-waterproof and permanent. All too often, attractively packaged colored inks are waterproof; they will damage your pens and give you less than satisfactory results. (If you are interested in writing in color, see Chapter 13.)

Both Italic and Copperplate can be written effectively with the same inks (i.e., an ink that's good for one is good for the other). Because there are more very fine lines in Copperplate than in Italic—although Italic too is characterized by a fine, elegant "hairline" (fine line)—a thinner ink is sometimes pleasant to use for Copperplate. Some fountain pen inks are particularly nice for practicing Copperplate, but be advised that fountain pen inks are often non-permanent.

Paper Although there is a vast amount of paper available in art supply stores, at this point we're going to limit our suggestions to practice paper (i.e., paper that can be used for calligraphic exercise, as opposed to calligraphic art). See Chapter 14 for information about good quality paper.

In order to practice effectively, without undue frustration, you will need to find paper that is smooth enough that your nib doesn't catch or bump along on the surface, but not so smooth that it will skid out of control. Furthermore, you want a paper that won't absorb the ink or bleed.

Most papers available in pads labeled *layout, visual bond,* or *marker* paper should be good for both Italic and Copperplate. The advantage of this paper is that it is thin enough that you can put guide lines under the sheet you are writing on and the lines will be easy to see through the paper. Sixteen pound bond paper—this refers to the weight per 500 large sheets—which is generally the weight of copy machine or computer paper, can be just the right thickness to enable you to see your guide lines. If the paper is too thick to see the lines, you'll have to draw lines on every sheet. This is not too difficult to do, but it can be time consuming.

Very thin paper, such as tracing paper or architects' vellum, rarely has a decent writing surface for pen and ink. You can easily see your guide lines, but the line quality of your calligraphy will be poor.

We suggest that you use 11" x 14" practice paper. This is a medium-sized format, large enough so that you won't feel cramped, but not so large as to be cumbersome.

How do you know if the paper surface is good for calligraphy? It is very easy to test the paper. Simply dip your pen into your ink and make a stroke (line) or two on the paper. If the paper absorbs the ink, the paper is not good. If the pen slides out of control, as it will on a glossy surface, the paper is too smooth. If the paper grips the nib ever so slightly, that is, if you feel a tiny bit of resistance as you move the nib across the page, the paper is probably okay.

There is a wider range of paper surfaces that can accommodate the Italic nib than the Copperplate nib. Both hands can be written on smooth papers, but, for the most part, a more textured paper causes difficulties for the sharp, pointed Copperplate nib. Textured paper may not be a problem—and indeed may produce interesting and beautiful results—when writing Italic.

The bottom line? Choose paper that gives you the best possible results. If your pen catches and snags in the paper, if the ink splatters or your letters are out of control, try a different paper. For exercise and practice, work on papers that permit you the greatest control of your pen and, consequently, the best letters you can form.

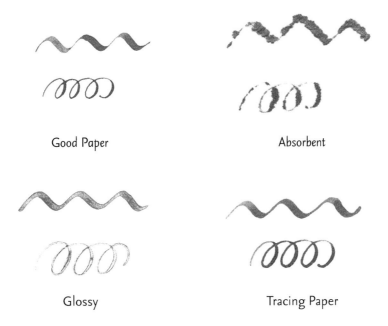

Good Paper

Absorbent

Glossy

Tracing Paper

Remember, too, that not every calligrapher likes the same papers. Your teachers' or colleagues' recommended papers may not work as well for you. By making your own tests, you can guarantee good results.

Other Recommended Materials Whenever you are working with pen and ink, you should equip yourself with some sort of water container (an old coffee cup, a small glass jar, a plastic container) and a cloth or paper towel. This should be part of your set-up, so that you never forget to clean your pens. It's a mistake to allow ink to dry and build up on your nibs. This will cause them to deteriorate and possibly corrode. It is easy to dip the nib into water and wipe it well with your towel. Do this on a fairly regular basis, every fifteen minutes or so when you are working, and every time you stop working, whether you are finished for the day or taking a break. If you keep your tools clean, and dry them well, they will last a long time.

Be sure to remove the nib from the penholder whenever you stop working. If you leave a damp nib in the penholder, it will rust.

Another simple and very worthwhile part of your set-up is a *guard sheet*. This is a piece of paper that covers the part of the writing surface upon which you rest your writing hand and perhaps your other hand as well. This protects the paper from the natural oils in your skin. By making a guard sheet part of your basic set-up, you won't inadvertently damage your writing paper by putting your hands or fingers on it.

For some of the work you do, you will also need a *ruler* and *pencil*. A metal ruler is a good investment because it usually sits quite flat on the paper, which enables you to draw lines more accurately than a ruler that is thicker, like a wooden ruler. A metal ruler and a cutting tool (a razor blade or craft knife) are used for cutting or trimming your paper. Thin plastic rulers are sometimes quite good for drawing lines, but can't be used for cutting.

A medium-hard pencil, such as a 3H, is good to have on hand for drawing lines; and a softer pencil—an HB for example—can come in handy for quick sketches and layouts. You should always have a few pencils and a *pencil sharpener* somewhere within reach.

And finally, an important part of your calligraphic set-up is carefully drawn, mathematically accurate *guide lines*. We'll discuss this in some detail in the following chapter.

ITALIC (ONLY)

Nibs The materials that are unique to Italic are the nibs (pen points). Italic is written with *broad-edged*—sometimes called *square cut*—nibs of varying widths. Here are a few examples:

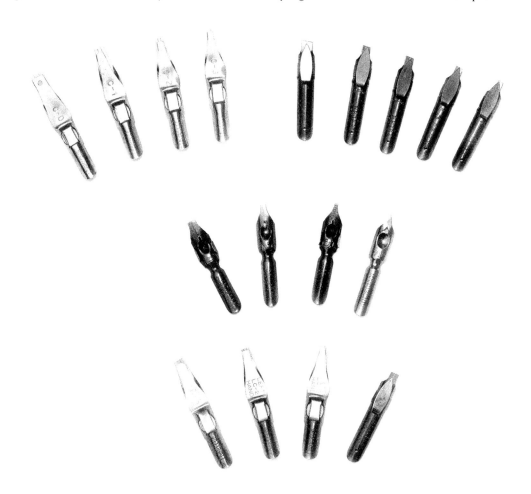

Broad-edged Nibs: top and middle row for right-handed calligraphers, bottom row for left-handed

There are many other writing tools that can be used for Italic calligraphy, including quills*, brushes, fountain pens, chisel-edged markers and even carpenters' pencils. For the purposes of this book, we're going to limit ourselves to dip pens, which are penholders with removable metal nibs. (An exception is Chapter 11, which discusses informal calligraphy written with some non-calligraphic tools.)

There are a number of brands of broad-edged metal nibs available. You will no doubt find some nibs easier and some more difficult to use, and will have better or worse results, depending on such factors as how hard you press and what kind of paper you are writing on. A more flex-

*A quill is a fine traditional writing tool. We suggest that you read about and experiment with quills in order to experience the most classical way of writing. Cutting quills and writing on vellum (calves' skin) are skills that need time and training to master. This is part of a traditional calligraphic education.

ible nib, such as the Mitchell Roundhand series, needs a lighter touch than firmer nibs, such as Brause, Tape, or Speedball.

Our personal preference is Brause or Mitchell. The instructions in this book will sometimes indicate a specific nib or choice of nibs for certain exercises. In each case, however, you are welcome to try other tools to see which produce the best results. The guide lines at the back of the book are ruled for Brause nibs, but other nibs of the same width can be substituted.

Italic Nibs for Lefties Speedball, Brause, and Mitchell all offer nibs specially manufactured for left-handed calligraphers. Many lefties find these nibs, which are cut slightly obliquely to the left *(see illustration on page 12)*, helpful in overcoming some initial difficulties in holding their pens correctly. A combination of a left-hand nib and paper slanted downhill to the right usually solves any problems left-handed students may incur.

Left Hand Paper Position Right Hand Paper Position

Penholders Just about any penholder that holds your nib firmly is acceptable. When you insert your nib in a penholder, it should stay securely in place without wobbling or falling out into the ink. Penholders can be smooth, rounded, faceted, lightweight, heavy, plastic, wood, paper-covered, cork-tipped, very cheap, medium-priced, or extremely expensive. *None* of this matters as long as the penholder is comfortable to hold and the nib stays in place.

Be sure to dry your penholder after cleaning your nib (you generally clean the nib while it is still attached to the penholder), especially if the end into which the nib fits is metal. Remove the nib and store it separately.

COPPERPLATE (ONLY)

Nibs and Penholders Copperplate nibs are very special tools. They are *pointed, flexible nibs*. Some of them, which are called *elbow nibs*, have a bend or kink in the middle.

Because Copperplate is written at a fairly extreme slant, it is necessary to hold the pen in a particular position (which will be explained in the next chapter). This is quite different from the pen position of most other alphabets. In order to hold our pens comfortably in this position, without undue strain on the wrist, we can choose from two nib/penholder combinations: an elbow nib in an ordinary penholder (the same penholder that is used for Italic), or a straight nib in a special Copperplate penholder, also known as an *oblique penholder*.

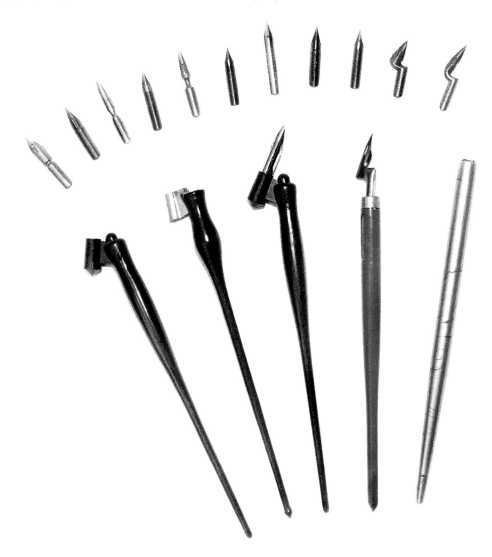

Copperplate Nibs and Penholders

There are advantages and disadvantages to both choices. If you choose to work with elbow nibs and straight penholders, you may be limited in your choice of nibs. Mitchell Copperplate (elbow) nibs are among the few available, unless you are lucky enough to come across some vintage (no longer manufactured) elbow nibs. Many people find the straight penholder a little more comfortable to hold than the oblique penholder, but the limited choice of nibs is a disadvantage.

The combination of straight nibs and oblique penholder gives you more options. Several companies make straight Copperplate nibs (Hunt, Gillott, Brause) in various sizes and flexibilities, and more interestingly, there are numerous vintage Copperplate nibs that appear from time to time in catalogs, shops, and on Web sites. The slight discomfort of holding the oblique penholder should be easy enough to overcome.

Our recommendation is that you try as many different Copperplate nibs as you can find, both elbow nibs and straight nibs. With practice, you'll be able to evaluate them and choose the ones you like best.

Copperplate nibs are more fragile than broad-edged nibs. They wear out fairly quickly and can be also be damaged inadvertently. Once you determine which nibs you like, always buy several at a time. One Italic nib may last quite a long time, but you'll find that you go through Copperplate nibs fairly rapidly if you are doing a lot of writing. (One "envelope job," e.g., addressing 100 or so envelopes, can use up quite a few Copperplate nibs!)

Copperplate Nibs for Lefties The good news is left-handed calligraphers don't need any special equipment for Copperplate. A straight Copperplate nib in a straight penholder, combined with carefully positioned paper should make learning Copperplate quite comfortable for lefties.

Some General Advice

It is a good idea to look at calligraphy mail-order catalogs for the best choice of nibs and inks. Local art shops often have a limited selection. The catalogs also provide information about the products they offer, and sometimes sell sample packets of nibs so you can try several different ones.

There are no absolutes when it comes to equipment, but the more pens, papers and inks you try, the more likely you'll be to discover the materials that work well for you.

Light Be sure that you have a good light source when you are practicing calligraphy. This can be natural light, if you are able to work near a window, or a lamp positioned so that your hand does not cast a shadow on the writing surface.

A good rule of thumb is for right-handed calligraphers to keep their light source either in front or to their left, and for those who are left-handed to keep the light to the front or to the right.

The light should be strong enough so that you can see your guide lines, whether they are under the paper or lightly penciled onto the surface of the paper. An artist's lamp, available in many art supply stores, is a good investment and does not have to be expensive. These lamps can usually be adjusted as you work, so that the light is directed exactly where you want it. Try to find one that can move up and down as well as to the left and right. These lamps often clamp onto your desk or work table, which is a very useful feature; they can be moved and repositioned to serve you best.

Posture Good posture makes a difference in the quality of your calligraphy. (Actually, *bad* posture can really make a big difference!) By sitting up straight with both feet on the floor, you will have better arm movement and thus better control of the pen. Your arm should be relaxed and comfortable, neither crushed against your side nor stretched out too far away from your body.

Try to avoid the temptation to sit on one leg, lean your head on your hand, or do calligraphy in a horizontal position.

Practice "Excuse me, how do I get to Carnegie Hall?"

"Practice, practice, practice."

Well, it's an old joke, but there is no magic pill that replaces the hours spent practicing your calligraphy. No one is born with perfect calligraphic skills and there are no master calligraphers who haven't put in the time to write and write and write.

Practicing calligraphy can be an endless source of pleasure, relaxation, and satisfaction. And the more you practice, the better you'll become. In this book we'll offer many suggestions that will make practicing not only productive and gratifying, but fun.

A Review of the Basics: Information Common to both Italic & Copperplate

There are certain principles and techniques that are shared by Italic and Copperplate and many that apply to one or the other of these hands. Let's begin with some information that is applicable to both.

CALLIGRAPHY VOCABULARY

The word *calligraphy* is defined as "beautiful writing." Whether you are learning Italic, Copperplate, or any of the many other styles of writing, it is only when your writing reaches a level of technical skill combined with harmony, grace, and rhythm that what you are doing can truly be called calligraphy.

Here are some words common to all calligraphy:

Hand a style of calligraphy (e.g., *the Italic hand*)

Minuscules lower-case letters

Majuscules capital letters (In this book we will use the word capitals.)

X-Height the height of the minuscule x and all the other lower-case letters that don't have ascenders and/or descenders

Ascender the upper part of the minuscule b, d, f, h, k, and l

Descender the lower part of the minuscule f, g, j, p, q, and y

Baseline the line upon which your letters rest, also known as the *writing line*, the line that defines the bottom of the letters that don't have descenders

Waistline the line that defines the top of the minuscule letters that don't have ascenders

Ascender Line the line that defines the top of the letters that have ascenders

Descender Line the line that defines the bottom of the letters that have descenders

Entrance Stroke the thin line with which most minuscule letters (and some capitals) begin, sometimes called the *lead-in stroke*

Exit Stroke the thin line with which most minuscule letters, and some capital letters, end

Counter the space inside a letter, also called the *negative space*

Hairline any fine line made by your pen

RELATIONSHIPS AMONG LETTERS

Both Italic and Copperplate can be analyzed in terms of *basic strokes* and *families of letterforms*. When learning either alphabet, understanding and practicing the basic elements of the letters will prepare you to write a visually integrated hand. In our explanation of basic Italic and Copperplate, we will divide the letters of each alphabet into groups with shared strokes or shapes. This will enable you to understand each alphabet in terms of its unifying principles.

SPACING

A *sine qua non* of calligraphy is good spacing. Spacing refers to the space between letters in a word (also called *letter spacing*) and the space between words in a line of writing *(word spacing)*. In both Italic and Copperplate, the same spacing rules apply, the most fundamental being *the space between letters in a word is visually equal to the space inside the letters*.

To apply this rule to Italic and Copperplate requires slightly different visual judgments, but the principle is the same.

GUIDE LINES

In most cases, using guide lines is not only a good idea, but a necessity. A lot of the instructions and exercises in this book involve precise measurements. We have provided a section at the end of the book that we suggest you photocopy in order to make your practicing and homework easier. These lines are numbered and labeled to correspond with the instructions in the chapters that follow. But it is very important to learn to draw your own guide lines. To do so, you'll need a sharpened 3H or 2H pencil, a good ruler—either thin plastic or metal, so that it stays flat on the paper—a protractor for Copperplate slant lines and a fine-point black marker. If your writing paper is sufficiently transparent, lines drawn with a black marker will be visible; if not, for example when writing on heavy-weight or colored paper, you will need to draw your lines in pencil directly on the paper.

For simple instructions for drawing your own guide lines, see Chapter 4 (for Italic) and Chapter 5 (for Copperplate).

A Review of the Basics: Italic Rules & Letterforms

Now let's consider the characteristics that are specific to Italic. Before we introduce you to (or review) the alphabet, let's look at the underlying principles of *pen angle, letter slant, pen scale,* and *proportions.*

PEN ANGLE

The term *pen angle* refers to the relationship between the edge of the nib and the baseline or any horizontal line on the page. The traditional pen angle for Italic is 45°, which looks like this:

45°

No matter which direction you move your pen—up, down, across, diagonally, or in a curve—this pen angle should remain constant.

LETTER SLANT

Italic letters are written at a slight slant off the vertical. Generally speaking, 5° to 10° is considered the standard slant, although some calligraphers like their Italic to be either more upright or more slanted. Most of the models in this book were written at 7°, but we'll also discuss variations on letter slant.

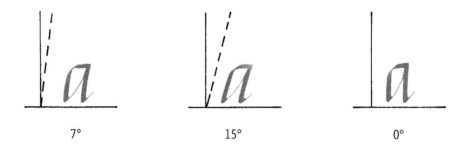

7° 15° 0°

SCALE

Here is another basic principle of Italic: *The height of Italic letters is in direct proportion to the width of the nib.* In the most general terms, this means that a narrow nib will produce a short letter and a wider nib a taller letter. But of course the relationship is more specific than that. The traditional x-height for Italic is five times the width of the nib. This can be measured visually by using your nib to make small marks on a strip of paper called *pen widths* or *nib widths*. Five nib widths, placed corner to corner, will look like this:

This measurement, or *pen scale,* can be used to rule lines on your paper.

Proportions

The proportions of Italic letters can be expressed in two ways: the relationship of the letter height to the nib width (as explained on page 20) and the relationship of the parts of the minuscule letters to each other (i.e., the proportion of the ascender to the x-height to the descender). In traditional Italic, the ascender, x-height, and descender are all equal. Thus, we have two formulas to remember:

$$\text{x-height} = 5 \text{ pen widths (x = 5 pw)}$$

$$\text{ascender : x-height : descender (a : x : d)} = 1:1:1$$

In Chapter 9 we will change both of these formulas to create variations in the Italic minuscule letters.

Drawing Your Own Guide Lines

Since the x-height, ascender, and descender are all the same length, the spaces on your guide lines will be equidistant. Here are simple step-by-step instructions for ruling a page:

1. Holding your paper horizontally and using a ruler, draw a line approximately 1" from the top, left, and right sides. This creates margin space around your writing.

2. Use a pen scale, carefully drawn at 5 pen widths, and mark off (by means of small dots) 5 pen-width spaces along the left and right margin lines.

3. Connect the dots. Be sure to position your ruler carefully so that your line spaces are really equal, not sort of equal.

THE LETTERFORMS

Many how-to books are available which are devoted exclusively to Italic calligraphy. In the interest of expediency—and because this is basically an intermediate level book—we're going to present this material in a fairly brief form. But be sure that you understand it thoroughly and practice it carefully before going on to the more advanced exercises in Parts II and III.

PEN ANGLE PRACTICE

Warm up with some 45° pen angle exercises. Try some *zigzags*, *downstrokes*, *cross-strokes* (horizontal lines), *crossed lines*, and *arches*. Practicing arches is a particularly good exercise, since they are a basic component of many Italic letters.

MINUSCULE LETTERS

The basic strokes of the Italic minuscules are the *entrance* and *exit strokes*, the *downstroke*, the *a-* and *b-shapes*, and the *ascender form*. Be sure your pen is held at a 45° angle!

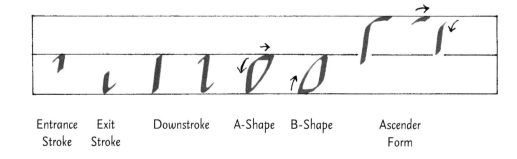

| Entrance Stroke | Exit Stroke | Downstroke | A-Shape | B-Shape | Ascender Form |

Many of the examples in this chapter were written with a 2 mm nib, but for the purpose of studying or reviewing Italic, it is a good idea to work larger. Try writing these strokes using a fairly wide nib, such as a Brause 3 mm or a Mitchell #1. Use Guide Lines #1 at the back of this book by photocopying the page and putting it under a sheet of practice paper.

The minuscule letters can be formed by combining the basic strokes and adding a few additional ones. Practice the letterforms in the following groups:

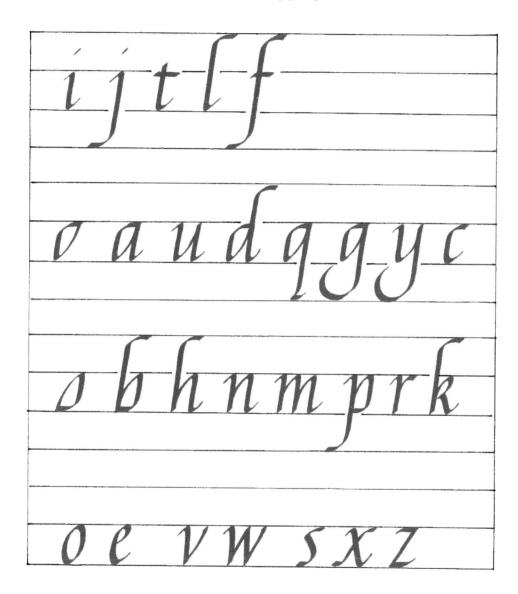

SPACING

The importance of good spacing cannot be overemphasized. Once you are familiar with the basic letterforms, try writing words. Remember to leave approximately as much space *after* each letter as appears *inside* the letter, using the letter a or n as a basic width.

Long words will give you more spacing practice than shorter ones. Try some of the ones illustrated here. You may find that letter combinations such as rr, ff, ch, ax, and any letters preceded by c or r are particularly challenging.

challenging

approximation

subsequently

blueberries

CAPITALS

Italic capitals tend to fall into two categories: simple, undecorated letterforms, called *Simple Capitals*, and flourished or *Swash Capitals*. There are numerous variations to choose from, making the study of Italic capitals an exciting and challenging part of calligraphic education.

Here's a basic Swash Capital alphabet to practice, arranged in family groups. These letters are about seven pen widths high, making them slightly less than 1½ times the x-height. We'll discuss the Simple Capitals and variations on the Swash Capitals in the chapters that follow.

Like the minuscules shown on the previous pages, these letters were made with a Brause 2 mm nib, but they should be practiced first using a 3 mm or a Mitchell #1 nib.

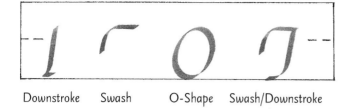

Downstroke Swash O-Shape Swash/Downstroke
 Combination

T F E P R B D I J

O C Q G

H K A M N

U V W

L S X Y Z

NUMBERS AND PUNCTUATION

There are two approaches to calligraphic numerals, the *Modern Numbers*, which are all of equal height, and the *Old Style Numbers*, which vary in both height and position relative to the baseline.

Modern Numbers Make these numbers slightly taller than the x-height, about the height of the minuscule t. (*Note:* Number height can vary with the needs of the text or the taste of the scribe. Experiment with different number heights to find ones that suit you.)

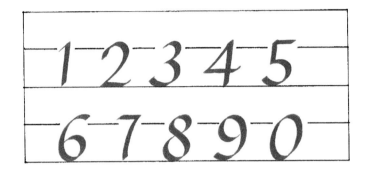

Old Style Numbers The 1, 2, and 0 are all x-height size. The 3 to 9 are the same height as the Modern Numbers but vary in their placement.

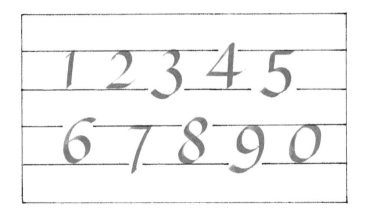

Punctuation Italic punctuation is made by writing standard punctuation marks with a broad-edged pen. The period is actually a little square sitting on its point.

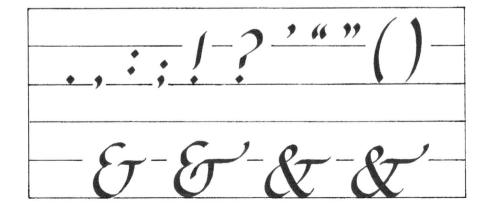

Chapter 5

A Review of the Basics: Copperplate Rules & Letterforms

In this chapter, we will first consider some basics: *pressure, letter slant*, and *proportions*. Then we will review the Copperplate *minuscules, capitals, numbers,* and *punctuation*.

PRESSURE

One of the most striking differences between the physical system of writing Italic and Copperplate is the pen movement necessary to produce thick and thin strokes. Whereas in Italic the variation in stroke weight (thickness) comes almost entirely from a combination of the pen angle and direction in which the pen moves, *thicks and thins in Copperplate are the result of pressure on the nib.*

As many of you know, and as shown in Chapter 2, Copperplate is written with a flexible, pointed nib. This nib, which has a central slit, responds to pressure by opening (the slit at the end separates), allowing an increased amount of ink to flow.

With your nib inserted in the penholder, but without dipping it into ink, press it lightly against your paper. A small amount of pressure will cause the nib to split or the end of the nib to separate. A greater amount of pressure will cause it to split more or open wider.

A basic principle of Copperplate is *press on the downstroke; release on the upstroke.* Every time you move your pen downward, press on the nib so that it opens. Release the pressure when making an upstroke or when continuing from a downstroke into an upstroke. When making letters, the varying pressure on the pen creates a pattern of thick and thin lines.

LETTER SLANT

Copperplate letters are written at a slant of 54° or 55° from the horizontal. This is a fairly extreme letter slant, compared to most calligraphic alphabets, as well as to most people's "normal" handwriting. In order that our pens function well, the end of the nib needs to be pointed in the direction of the letter slant. There is some leeway allowed in this rule; the nib can point within about 20° off the slant lines, in the direction of the vertical.

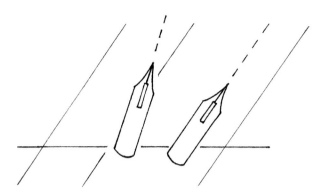

Within this range, the nib will open easily as you make your downstrokes.

When practicing basic strokes and Copperplate letterforms, be sure your nib doesn't drift too far to the left. If the nib is pointing too far away from the "safety zone," it won't open properly when you apply pressure, and your strokes will be ragged.

Use the Copperplate guide lines in the back of this book, which have mathematically accurate slant lines, or, if you prefer, draw your own guide lines. If you draw your own lines, be sure to include slant lines as well as horizontal lines. Unless you are quite experienced in Copperplate, the support of slant lines is an invaluable aid in keeping your letters parallel and correctly slanted. Don't let anyone tell you slant lines are a crutch!

PROPORTIONS

Since Copperplate nibs have no measurable width, we cannot base x-height on nib width. We do, however, use the term x-height to describe the height of the minuscule letters, but the x-height measurement is one that we can choose for ourselves.

Because of the limitations of Copperplate nibs (the amount of flexibility available without sacrificing control) we tend to make Copperplate letters relatively small. For most of the exercises in this book, we'll suggest an x-height of ¼", which is the measurement of the x-space on Guide Lines #2. Working smaller—between ⅛" and ¼"—is also very practicable, as is working slightly larger. We'll discuss and experiment with variations in size in Chapter 6.

Once the x-height has been established, the height or length of the ascenders and descenders of the basic minuscule letters (as opposed to letter variations) can be determined, based on this standard relationship: the ascender and descender are equal to each other and 1½ times the length of the x-height. Thus, the minuscule proportions may be expressed in mathematical terms:

$$a : x : d = 1\frac{1}{2} : 1 : 1\frac{1}{2} \text{ or } 3 : 2 : 3$$

On our basic Copperplate guide sheet (Guide Lines #2), the x-height measures ¼″ and the ascender and descender each measure ⅜″.

It is very interesting to change these proportions, as you will see in Chapter 9.

DRAWING YOUR OWN GUIDE LINES

To draw guide lines for Copperplate, you will need to use your ruler and protractor accurately and, as you do in Italic, connect the dots. Here are instructions for a sheet with 1½ : 1 : 1½ proportions. (*Note:* These lines are the same as those on Guide Lines #2. This technique is applicable to drawing any Copperplate guide lines.)

1. Hold your paper horizontally and rule a 1″ margin line at the top, left, and right.

2. Using a ruler and sharpened pencil, measure from the top of the outlined space along the left and right margins: ⅜″, ¼″, ⅜″, ⅜″, ¼″, ⅜″, etc. Be sure that you have spaces for all three parts of the minuscule letters each time (i.e., ⅜″, ¼″, ⅜″, ¼″ is *not* correct).

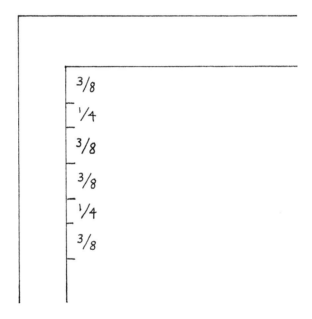

3. Connect the dots carefully.

4. Holding your protractor so that it lines up with any horizontal line and the vertical line of the left margin, make two marks: one at the bottom center-point of the protractor and one at 55°. Remove the protractor and connect those two dots. This will give you a basic slant line.

5. Draw lines parallel to the basic slant line, about ½″ apart.

Copperplate, like Italic, can be broken down into its component elements, or basic strokes.

Basic Strokes Practicing the following strokes will prepare you well for the Copperplate minuscules. Not only are they the fundamental forms of the letters, but practicing them will help you develop and maintain the consistent pressure required for the downstrokes. This is also a good time to concentrate on letter slant.

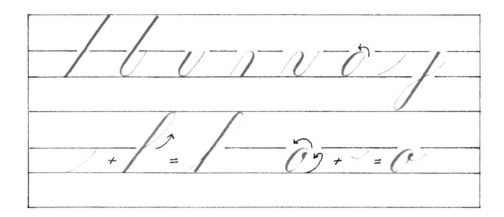

Practice these strokes until all the thick strokes are of equal weight and all the forms are parallel.

Minuscules Like Italic, Copperplate minuscules can be studied in family groups. The letters consist of the basic strokes with very little added.

It is important to remember that these letters are mostly made of *individual strokes*. Each stroke ends fully before the next one begins. The m, for example, is written in three separate but overlapping strokes, and the a is written in two.

Be sure to come to a full stop and remove your pen from the paper after each stroke. This will enable you to control the details of each letter and avoid making sloppy, unfinished letters.

/ + J + / + t + U + C + C + U + J + / + J

success

good not good

Lifting your pen after each stroke also slows you down. This is good. Although Copperplate has the appearance of a cursive (rapidly written) script, it must, in fact, be written slowly and even painstakingly to achieve a graceful, elegant result.

Ligatures Although Copperplate minuscules are written stroke by stroke with many pen lifts, words written in Copperplate give the appearance of continuous motion. This is because Copperplate is *visually* a cursive hand, one in which the letters are connected to one another. These connections are called *ligatures* or *joins*.

In many cases, the letters are joined by combining the exit stroke of the first letter with the entrance stroke of the letter that follows, thus:

O + l + l = ai

/ + l + u + v = un

O + 2 + C = ox

/ + J + / + t = st

As you can see, the exit and entrance stroke combine to form a single connecting stroke, but the pen must stop—or at least pause—at the end of each stroke before beginning the next stroke.

Letters that have an exit stroke that are followed by letters that do not have an entrance stroke (the o-group letters) also *look* as if they were written continuously, but you must stop after the exit stroke of the first letter and move your pen to the starting point of the o-shape, which is on the right side. The second letter joins to the first by curving backwards—in a counter-clockwise motion—to meet the exit stroke of the first letter.

$$, + t + \hat{o} + \smile = to$$

$$1 + 1 + \iota + \hat{o} + \iota = ma$$

In order to join your letters gracefully, try to remember to end every letter with an exit stroke that is long enough (more than halfway up into the x-space) to make the connection invisible. This will give your letters the appearance of continuous motion (i.e., writing without stopping)—or *cursive calligraphy*—even though your pen has stopped and started numerous times. With practice, these stops will become brief pauses, which will permit your nib to open or close as necessary to create clean, well-formed letters.

And don't forget when joining the minuscules, always be aware of the spacing rule:

the space between letters

is visually equal to the

space inside the letters

Capitals Copperplate capitals are in glorious contrast to the simple, somewhat sober minuscules. There is an enormous selection of capitals to choose from, especially if you start to collect examples from the scribes of the eighteenth and nineteenth centuries.

In this chapter, we'll show you one version of each letter, with many more to follow in Chapter 8.

The basic strokes of the capitals are the double-curved *downstroke*, the *upstroke*, the *o-form*, and the *flourishes*, which are spirals and loops that embellish the basic letterforms.

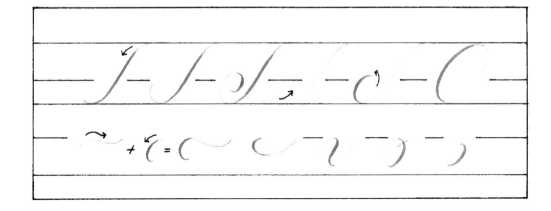

Once you are familiar with these strokes and shapes, you can try the capitals. They are the height of the minuscule h or k (i.e., an x-height plus ascender space).

In this illustration, the capitals are organized by family group, based on the downstroke, upstroke, and o-form, plus a few exceptions. You can substitute loops for spirals (and vice versa) and vary the ornamental strokes at the beginning and ending of the basic downstrokes.

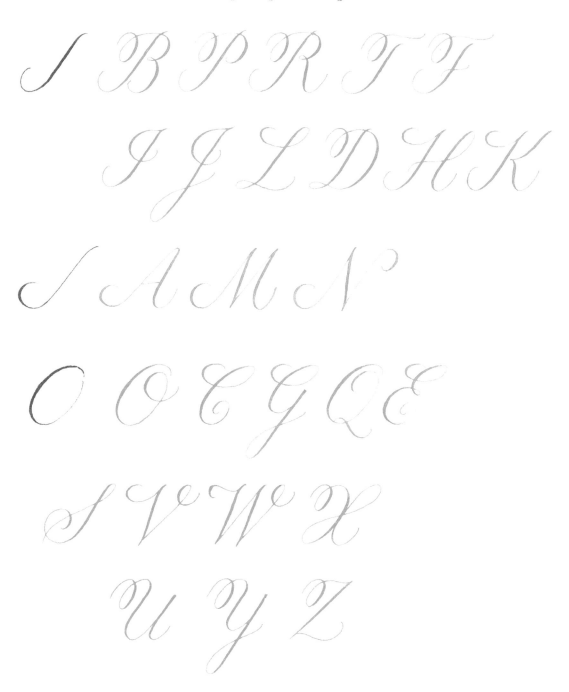

Numbers and Puctuation When making Copperplate numbers, like Italic numbers, you have two size/position options, the *Modern* and *Old-Style* numbers.

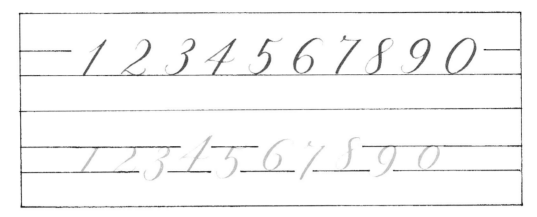

Top Line: Modern Numbers, Bottom Line: Old-Style Numbers

When spacing numbers, allow them a little breathing space. They should be visually equidistant from each other, but never too close.

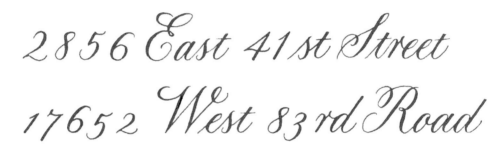

Copperplate punctuation is relatively simple. Be sure to make the period—which reappears in the colon, semi-colon, exclamation point, and question mark—by drawing a very small circle and filling it in. Don't apply pressure to your nib or the circle will be irregular.

HOMEWORK

Try writing a short quote or simple text in both Italic and Copperplate. About 25 to 30 words should give you four or five lines of writing. Use the same guide lines you used to practice the alphabet.

Write the text with a simple flush-left format (i.e., all lines begin directly below each other). This gives you a straight left margin.

Concentrate on carefully constructed letterforms, good spacing, and, for the Copperplate version, invisible ligatures. Evaluate your writing in terms of consistency of letter shape, weight, and slant. See if you can feel the rhythm of the calligraphy while you are writing and *see* the rhythm in the writing after you finish. (This is tricky!)

It is also interesting to compare the results and see which hand expresses the meaning of the words more successfully. Sometimes the results are equal, but sometimes one hand or the other seems more appropriate to the text. This is a judgment that you will find yourself increasingly able to make, as your proficiency improves.

Here is an example: These two texts were written larger than they appear, using the same guide lines that you are using, but were subsequently reduced to fit the format of this book. These lines are from *The Passionate Shepherd to His Love* by Christopher Marlowe.

Come live with me and be my Love,
And we will all the pleasures prove
That hills and valleys, dale and field
And all the craggy mountains yield.

Come live with me and be my Love,
And we will all the pleasures prove
That hills and valleys, dale and field
And all the craggy mountains yield.

PART 2

Calligraphy Continued : & Letter Variations

Variations in Size

The size of Italic and Copperplate letterforms is certainly not limited to the measurements of your basic guide lines. Once we are accustomed to 3 millimeter nib-height Italic and ¼ inch x-height Copperplate, we are ready to try to write both alphabets larger and smaller.

We write larger for many reasons: to make a strong or bold statement, to catch the attention of the reader (for example on a poster or sign), to create contrast in a piece of calligraphy, or simply for the pleasure of making big letters.

Smaller writing serves many purposes. In commercial calligraphy, we reduce the size of our Italic and Copperplate when we address envelopes, write place cards or escort envelopes, and sometimes when writing text in documents, such as awards and citations. We also often use small writing in calligraphic artwork so that a long text can fit on a reasonable size paper.

Writing larger and smaller is approached very differently in Italic and Copperplate; the former requires that we change pen nibs and the latter that we change the pen pressure. But when writing either alphabet, we must always maintain the integrity of the forms and try not to sacrifice calligraphic principles—consistency of shape, slant, pen position, and *always* good spacing.

It's a good idea to see how far we can comfortably go when increasing or decreasing the size of our writing; there are limits beyond which the quality deteriorates. "Comfortably," in this case, refers to both physical and visual ease (i.e., how it feels to write bigger and smaller and how the calligraphy looks).

ITALIC: WRITING SMALLER

In order to decrease the size of our Italic letters without altering their weight, the relationship between nib width and letter height must remain constant. For the purposes of this chapter (and this will change dramatically in Chapter 9), no matter how wide the nib may be, the same formula applies: x-height = 5 pen widths. Here's an example of words written with 3 mm, 2 mm, and 1 mm nibs with the standard x-height/nib width relationship:

large size

3 mm

smaller writing

2 mm

quite small

1 mm

Use Guide Lines #3 and the upper half of #4, which are ruled for 2 mm and 1 mm nibs. With appropriate nibs for each guide sheet, try writing the Italic alphabet, followed by some words or sentences. You will probably find that it is a little easier to write with the 2 mm nib than the 3 mm, but beware of increasing your speed. Writing smaller often tempts us to write faster, which generally results in less carefully formed letters. Even very experienced calligraphers have to keep themselves from writing too quickly!

Now try a ¾ mm nib, using the bottom half of Guide Lines #4. The ¾ mm nib is often used to address envelopes and inscribe place cards. When working this size, be very careful that you regulate the flow of ink from your nib so that your hairlines remain fine.

The five pen-width relationship between the x-height and the width of the nib maintains the traditional visual balance between the black (or colored) line and the white space inside the letter (the counter). As you will see in Chapter 9, a shorter or taller x-height, such as four pen-widths or six pen-widths, will change this balance considerably.

Italic: Writing Larger

Using Standard Nibs Italic can be written quite a bit larger than the calligraphy produced by a 3 mm nib, without losing its legibility or beauty. The Brause nib series includes two larger sizes, 4 mm and 5 mm; the largest Mitchell is #0, which is a little smaller than a 4 mm. Speedball also makes some wide nibs, C-0 and C-1. Here are examples of words written with some of these nibs:

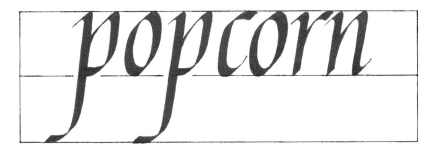

#0 Mitchell

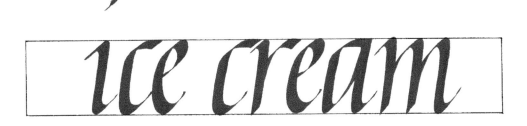

4 mm Brause

C-0 Speedball

5 mm Brause

When you practice using these larger nibs (on Guide Lines #5 and #6 for Brause 4 mm and 5 mm), you'll need to move your arm more than you do when working smaller. Some people prefer to work standing up rather than sitting when writing this size. This is a good idea because when you are sitting, your forearm usually rests on the table, which restricts arm movement. When you write standing up, only your hand rests on the writing surface. This increases ease of mobility. Try it both ways, sitting and standing, and see which works better for you. (*Note:* If you are tall and want to work standing up, you may need to raise the surface of your table or work space so you don't have to bend over too much.)

Using Other Tools Sometimes we want to write Italic even larger than the 5 mm nib permits. In fact, Italic can be used effectively as a "sign-writing" hand, to make posters and signs on large sheets of heavy paper or illustration board.

Special broad-edged poster pens are available that will enable you to make Italic letters that are several inches high. Look in the mail-order catalogs to see which tools and how many sizes are available.

Remember that the nib width must be multiplied by five to give you the x-height. Thus, a 2.5 cm poster pen (which is nearly 1″ wide) will make a 12.5 cm (about 5″) high minuscule x, which means the k or h will be 25 cm (10″) and the capitals will be about 17 cm in height, or 7″.

It takes a fair amount of practice to make such large letters. We'll discuss sign writing in more detail in Chapter 15.

COPPERPLATE: WRITING SMALLER

Changing the size of Copperplate calligraphy is done by decreasing or increasing the pressure on the nib. In order to write smaller, you will need to practice making your downstrokes with *reduced but equal amounts of pressure*, that is, every downstroke must be equal in weight to every other downstroke written that size.

Just how much pressure to use—which will determine the weight of the thick strokes—depends on the height of the letters. Notice the variation in the thick strokes in the example below:

example example

example example

Also notice that the thickness of the thin lines is the same in these four examples. This is because the same pen was used throughout; only the pressure changed.

Try writing Copperplate in four different sizes. Use Guide Lines #2 (Basic Copperplate) and Guide Lines #7 and #8 which are increasingly small but maintain the 3 : 2 : 3 ratio of basic Copperplate.

The best way to get used to writing smaller is by practicing for a reasonable amount of time using each guide sheet before moving onto one with smaller line spaces. Thus, write a page or two using Guide Lines #2, followed by a couple of pages using #7, and then try Guide Lines #8, (which is divided into two parts; the top half is a little larger than the bottom). This will help your hand become accustomed to the pressure variations. And of course, once you have determined how much pressure is necessary for each size, be sure to maintain that amount of pressure—and therefore that stroke weight—whenever you make letters of that size.

COPPERPLATE: WRITING LARGER

Writing larger Copperplate also requires a pressure change; in this case, you will need to increase the pressure on your nib. This will produce a thicker downstroke.

We're going to use Guide Lines #9 and #10. The lines on #9 are ruled with an x-height of $5/16″$. Since the ascender and descender are 1½ times that amount, they measure $15/32″$. This is 125% of the measurement on Guide Lines #2.

Guide Lines #10 is 150% of the basic measurement, or ⅜″ x-height and 9⁄16″ ascender and descender lengths.

These may sound like tiny increments, but the differences in your letters will be very apparent. It's a good idea to try writing on the 125% lines first and then the 150% in order to accustom yourself gradually to the increased amount of pressure needed for larger writing. Be extra careful to exert consistent pressure on the nib so that your thick strokes are all the same: slightly thicker than the basic weight when working on the 125% lines, and a little thicker than that on the 150% lines.

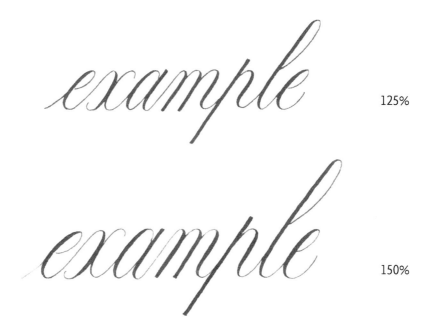

125%

150%

Neither of these sizes should present too much difficulty, but remember that when you work larger your mistakes are magnified! And of course a ⅜″ a isn't all that much bigger than a ¼″ a, but the f will be quite large and the capitals will be considerably bigger!

OTHER COPPERPLATE NIBS

As demonstrated above, Copperplate can be written in many different sizes with the same nib, by varying the pressure on the nib. But you can also try writing with other Copperplate nibs. Some nibs are more flexible than others, which means that you can make a heavier line with the same pressure you'd exert on a less flexible nib to produce a lighter-weight line; and of course the reverse is true: a less flexible nib will make a lighter weight downstroke. If you have a variety of Copperplate nibs, you can benefit from their varying flexibilities. And the only way to determine which nibs serve you best when writing various sizes is to test them.

Testing Your Nibs This is fun to do, but you need to be well organized and make careful notes.

Using a sheet of smooth practice paper and an ink that gives you a nice thin line, make one or two small letters and one or two large ones with each nib. Before switching from one nib to next, be sure to write the brand name and number (if there is one) under or next to each example, as well as any comments you may want to note about the quality of the nib. If you neglect to do this, you won't remember which nib made which letters and your test sheet will serve little or no purpose.

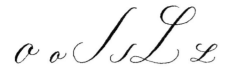

Brand Name...

Nice smooth action - works well large & small.

Brand Name...

A bit scratchy on the upstroke. Works better small.

Brand Name...

Lovely nib! A winner, big & small.

Brand Name...

Nib is too long - hard to control.

Brand Name...

Quite stiff - good for very small writing.

Brand Name...

Flexible, nice thick/thin contrast.

Brand Name...

Not great - uneven ink flow.

Brand Name...

Quite flexible with lovely hairlines.

You will notice that no brands are identified in this example. It is important to do your own nib tests, rather than relying on the recommendations of others.

The results of your nib tests will help you select the best nibs for the size you are writing. As you can see, some nibs, especially the stiffer, less flexible ones, don't work very well on large scale letters, but give you very good results when working small. And some of the more flexible nibs are a good choice for larger writing, but too flexible for small Copperplate. But always remember—these are personal choices; use the nibs that work best for you.

Furthermore, the results of testing nibs depend on the paper you are writing on, the ink or paint you are writing with, and the amount of pressure you exert on the nib. Nib tests on various papers are a valuable tool for the calligrapher: You might want to try your different nibs on such surfaces as envelopes, drawing paper, and charcoal paper to see which nibs work best on each surface.

HOMEWORK: CONTRASTS OF SIZE

This assignment is a bit challenging. Try to complete it in Italic first before doing it in Copperplate, or vice versa (i.e., don't switch back and forth; it's too confusing).

Choose a short text that can logically be divided into two parts, such as a quote in one language followed by its translation in another language, or perhaps a poem that has one important line (or some words you wish to emphasize), followed by (or preceded by) less important lines.

Write this text in two sizes, with larger size writing for one part of the text and a smaller size for the other part, using the guide lines appropriate for each size. It's a good idea to write your text out in pencil first to get a rough idea of how to divide it and how big the big part should be and how small the smaller part should be. (Use your guide lines for this as well.)

Be sure that the two sizes are sufficiently different from each other that you create a visible *contrast* between the larger and smaller writing. This will emphasize the difference; if the contrast is insufficient, the effect of writing in two sizes will be diminished or lost.

You may need to do this exercise more than once to achieve a satisfactory result. Doing your preliminary work in pencil rather than in ink often makes it easier to make good decisions and can save you a lot of time.

"*Good speed!*"

cried the watch,

as the gate-bolts undrew;

"*Speed!*" *echoed the wall*

to us galloping through...

Though much is taken,
much abides, and though
We are not now that strength
which in old days
Moved earth and heaven,
that which we are, we are~

Variations in Form : The Minuscules

Whether working in Italic or Copperplate, the temptation to experiment with variations in letterforms is irresistible. If we look at historical manuscripts, such as the writing books of the Italian Renaissance and the fabulous exemplars of the eighteenth century English writing masters, we find a wealth of possibilities.

Although this chapter will give you quite a lot of material to work with, we also advise you to look at historical models and start collecting books or photocopied examples that reproduce the best of the primary sources for these two scripts.

ITALIC MINUSCULE LETTERS

There are many possibilities for changing the form of Italic letters without altering the basic five pen-width x-height, the slant, or width of the letters. (*Note:* Slant and width can also be altered, but this changes the character of these letters a little too dramatically for our purposes. We'll take a brief look at these possibilities a little later in this chaptcr.)

We will, however, make some changes in the minuscule ascender and descender length. As you will see, simpler ascender forms "sit better" in a shortened ascender space; more decorative ascenders and descenders need a little extra space.

Simplified Ascenders and Descenders Minuscule ascenders can be simplified by leaving off the horizontal stroke at the top and replacing it with a stroke similar to the basic entrance stroke, but with a very short hairline, or by making a totally unadorned top, like the top of the lower-case t.

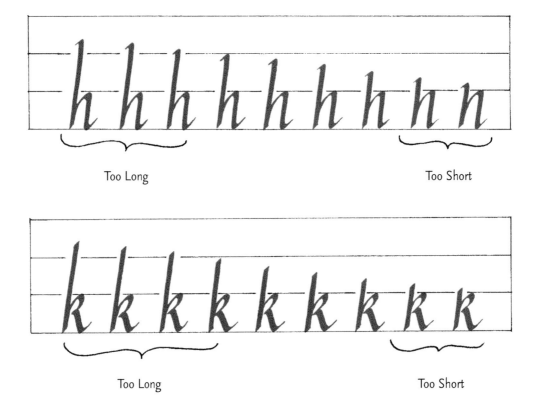

These two ascender tops can be used on the b, d, h, k, and l, but not on the f.

Experiment with different ascender lengths to determine how long they should be to balance the five pen-width x-height. You will find that there is a range of acceptable lengths, but the letter should be neither too long nor too short. If the ascender is too long, the letter looks awkward; if it is too short, legibility is sacrificed.

Too Long Too Short

Too Long Too Short

The descenders of the g and y can also be simplified by foregoing the teardrop shape and replacing it with a less decorative stroke. These new forms can also be written in a shorter descender space.

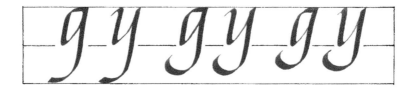

The descenders of the f, p and q can be simplified as well, and the j, which has a simple descender, can be shortened.

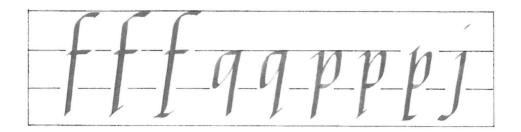

Decorative Ascenders and Descenders The addition of extended or curved lines can enliven your ascenders and add a decorative flourish to a line of writing. When making these more elaborate forms, you'll need to extend the length of the ascender. Try experimenting with this length by increasing it in small increments.

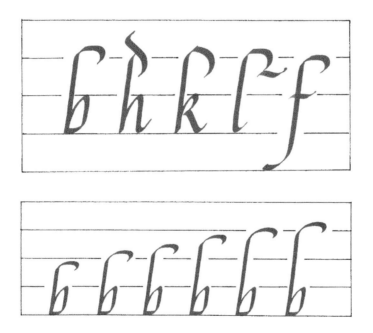

Decorative ascenders generally need to be written in two strokes, starting with the downstroke and finishing with the stroke at the top.

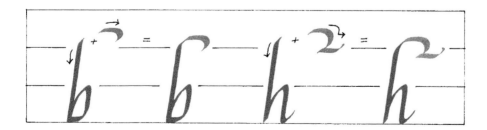

Descenders can also be more decorative by extending these strokes to the left or right or add-ing the occasional looped flourish at the bottom.

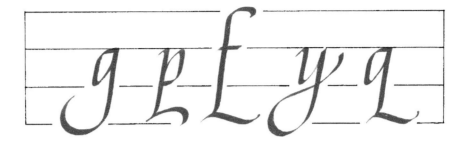

This doesn't work as well on the j as it does on the other letters.

Other Minuscule Variations By changing some details of your basic Italic letterforms, you can add some lively variations to your calligraphy without sacrificing any of the principles of pen angle, scale, width, or family resemblances.

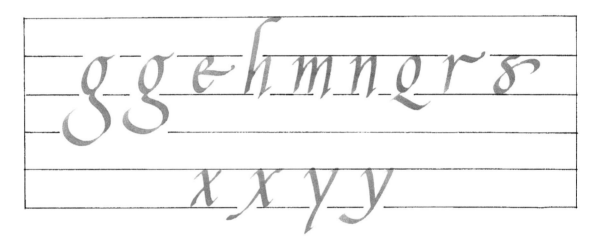

These relatively easy variations allow you to write Italic in two very interesting new ways—a simple, more sober alphabet, and a much more decorative one. In addition, you can include other variations in form in order to give your lettering some individual personality.

Changing the Width of Italic Minuscules This can cause some difficulties. As the width changes, your letters start to appear less and less like Italic, especially when you make wider letters. It is, however, interesting to experiment to see what happens when you increase or decrease your basic letter width (i.e., the *a-* and *b-shaped* letters).

Once you establish a new basic width (whether wider or narrower), you'll need to write the entire alphabet with the same—*or visually equal*—width letters, and also adjust the spacing to conform with the counters of the letters.

This is fun to play around with, and if handled carefully, can take you into the area of experimental calligraphy.

Changing the Slant To experiment with variations in letter slant, start by ruling slant lines on a guide sheet. Use a protractor to measure the degree of slant accurately. A good way to proceed is to draw horizontal guide lines for Italic with 3 mm and 2 mm nibs, make several photocopies of each, and then rule different slant lines on each page. Rule your lines at 5°, 10°, and 15°, and also a page with vertical lines.

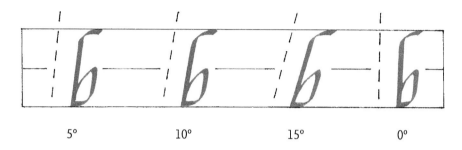

5° 10° 15° 0°

Then write a few lines using each new guide sheet, paying careful attention to the slant lines.

This is written at 5 degrees off the vertical.

The second line is slanted at 10 degrees.

Fifteen degrees is a more radical slant.

And this line isn't slanted at all.

COPPERPLATE MINUSCULE LETTERS

The variations possible for Copperplate minuscules fall into the same groups as those for Italic — simpler and more ornate ascenders and descenders, and a few new letterforms. And, like Italic, it is necessary to vary ascender and descender length to create the most harmonious balance among the parts of the letters.

Simplified Ascenders and Descenders Most basic Copperplate ascenders and descenders are characterized by loops. To simplify these forms, we replace the loops with either straight lines, hairline strokes, or curves of varying lengths. In most cases, these ascender and descender forms need less space than the standard looped forms.

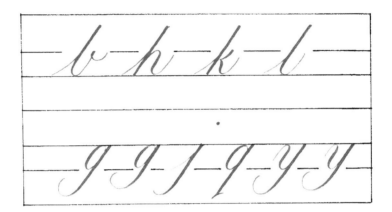

Notice that these forms can be effective in relatively little space, but if the ascenders are too short, the letter becomes ambiguous. If a simplified ascender is too long, it compromises the balance of the letter.

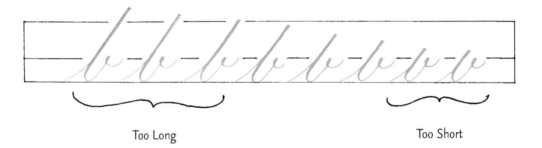

Too Long Too Short

The d and p are already simple forms, but variations are also possible.

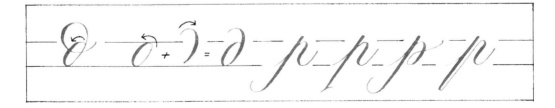

The ascenders and descenders of Copperplate minuscules can be looped and swirled endlessly, but we'll start with some relatively simple flourishes.

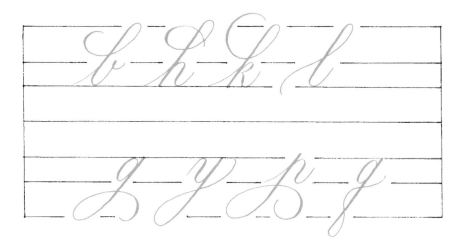

You'll need to allow a little extra space, especially for the ascenders, in order to accommodate these forms.

The f is a special letter. Since it has both an ascender and a descender, there is a particularly wide range of variation possibilities.

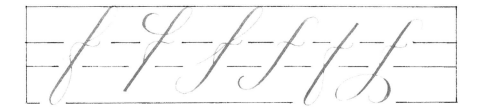

Try to add a bit more panache to your ascenders and descenders.

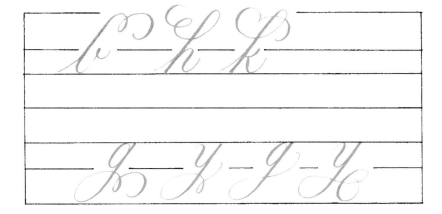

Other Minuscule Variations There are several other minuscule letters that have alternate forms.

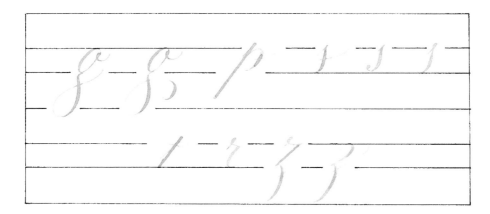

Changing the Width and Slant of Copperplate Minuscules Although it is not impossible to vary the width and slant of Copperplate minuscules, it can be difficult to achieve consistent results. A rounder or more upright script can be an effective (and beautiful) pointed pen alphabet, but often can't be considered traditional Copperplate.

Here are examples of the work of two calligraphers who specialize in pointed pen variations:

abcdefghijklmnopqrstuvwxyyandz

*The graphic signs called letters are
so completely blended with the stream
of written thought that their presence
therein is as unperceived as the ticking
of a clock in the measurement of time.*

William Addison Dwiggins

MIKE KECSEG

Mike Kecseg

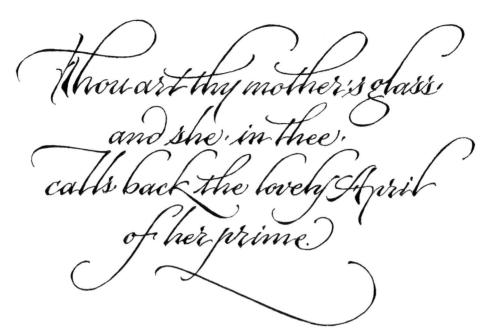

Barry Morentz

LEARNING FROM THE PAST

A time-honored way to learn calligraphy is by copying beautiful examples of the script. It is a good idea to select something that has simple, well-formed letters in order to be able to see how the letters are formed.

This example from *The Universal Penman* is a very simple minuscule alphabet that shows elegant letters, consistency of form, and beautiful spacing. Try copying this and compare your results with the original. You can even trace it once or twice to familiarize yourself with the width and weight of the forms.

Round Text.

Aabbcdefffghhhijkkkllmn opppqqrzfstttuvvnxyyyz·

Joseph Champion, The Universal Penman

But do be aware that these letters come from engraved forms, not pen-written, which means that in a few places there are some heavier strokes that don't come from pressure on the downstroke, such as the slight extra weight visible on the right side of the e and on the outside curve of the ascenders. Try to approximate what you see without worrying too much about these occasional anomalies.

HOMEWORK

These two assignments should be done in both Italic and Copperplate—separately, not in the same text.

I. Choose a text that you like, perhaps a few lines of poetry. Write the text first using the simplest possible letterforms, and then using more decorative ascenders and descenders. The Italic examples that follow were done with a 2 mm nib on Guide Lines #3. The lengths of the ascenders and descenders were estimated. The Copperplate examples were written using Guide Lines #7. In the second—more flourished—version of each text, an extra space was left between lines to allow for the decorative strokes. (All four examples were reduced to fit the format of this book.)

Such life here, through such lengths of hours,

Such miracles performed in play,

Such primal naked forms of flowers,

Such letting nature have her way

While heaven looks from its towers!

Such life here, through such lengths of hours,

Such miracles performed in play,

Such primal naked forms of flowers,

Such letting nature have her way

While heaven looks from its towers!

Such life here, through such lengths of hours,

Such miracles performed in play,

Such primal naked forms of flowers,

Such letting nature have her way

While heaven looks from her towers !

Such life here, through such lengths of hours,

Such miracles performed in play,

Such primal naked forms of flowers,

Such letting nature have her way

While heaven looks from her towers !

2. Choose a four to six line text with lots of ascenders in the first line. Write the first line using flourished ascenders and the rest of the text with simplified (shortened) ascenders and descenders. (Optional: You can make flourished descenders in the bottom line, if there are some letters with descenders.) These examples were also reduced.

Full fathom five thy father lies
Of his bones are coral made
Those are pearls that were his eyes
Nothing of him that doth fade
But doth suffer a sea-change
Into something rich and strange.

Full fathom five thy father lies
Of his bones are coral made;
Those are pearls that were his eyes
Nothing of him that doth fade
But doth suffer a sea-change
Into something rich and strange.

It is interesting to compare the results written in Italic with those in Copperplate. Is one alphabet more effective in simplified form? Is one more successful flourished? Do both styles of calligraphy express the meaning of the text equally well, or do you find one more appropriate than the other?

Keep in mind, of course, that the success of this kind of exercise also depends on your level of skill with each alphabet. If, for example, your Italic is better than your Copperplate, you will probably be more satisfied with the Italic results. But keep practicing; once your level of skill increases, exercises like this will produce beautiful calligraphy.

Variations in Form: The Capitals

Ah! The capitals! An entire book—two books in fact—can be written about Italic and Copperplate capitals. In this chapter, we're going to look at a variety of capitals, following a sequence similar to that of the minuscule variations: some simplified letterforms followed by more decorative or flourished ones. Also included are some models from the sixteenth and eighteenth century writing masters.

The basic principle for both Italic and Copperplate is the same: capitals serve, for the most part, as a contrast to the lower-case letters. They are taller, wider, and often more intricately shaped than the minuscules (though we'll look at some very simple letters as well). More often than not, writing in all capitals is discouraged, but we're going to show you how and when you can break that rule.

ITALIC: SIMPLE CAPITALS

The *Simple Capitals* are not just simplified forms, but a complete alphabet that is commonly known by that name. A standard comment by calligraphers is that these letters may be *simple*, but they are not *easy*.

The simple capitals are a slightly condensed, slanted form of Roman capitals. They are unornamented but nonetheless graceful and elegant. These letters are written parallel to the Italic minuscules, at a letter slant of 5° to 10°, and are a little shorter than the swash capitals, measuring approximately 6 to 6½ pen widths.

What makes learning simple capitals a little more difficult than swash capitals is their pen angle. Most of these letters are written at a 30° pen angle, which is flatter, relative to the baseline, than the 45° pen angle.

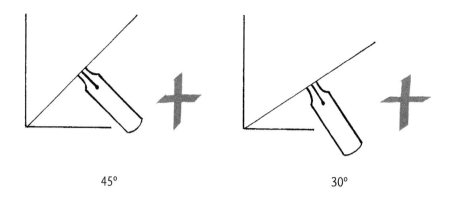

45° 30°

And to make this more complicated, not every stroke of every letter is written at 30°; the diagonal strokes—from upper left to lower right—are at 45°. Here are the basic strokes:

Serif 45° stroke

Before you try the alphabet, practice making some strokes at 30°. It's actually an easy pen angle, but if you are used to writing at 45° you'll need to concentrate so that the pen doesn't slip into the familiar 45° position.

Practice the simple capitals in family groups, starting with the easiest ones, the T, F, L, E, H, K, I, and Z.

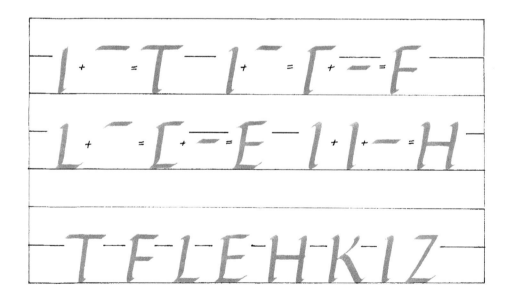

Next try the O-group and the other letters with curved strokes.

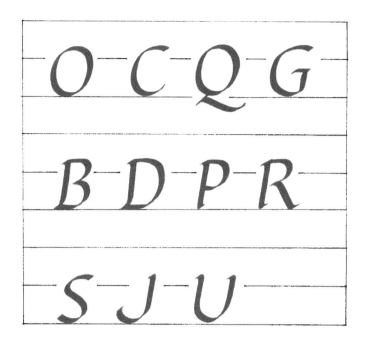

The third group of letters includes those that have 45° diagonal strokes. In our example, the 45° strokes are written in purple. The N is a special case because the pen is held at 45° for all three strokes.

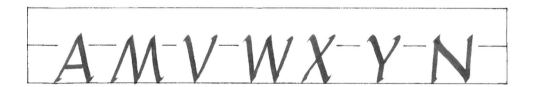

You may need to write the simple capitals a little more slowly than the swash capitals, partly because of the varying pen angle, but also to avoid making the entrance and exit strokes too long or too round.

Correct Incorrect

Write some words or names starting with simple capitals. Look for words that have ascenders and/or descenders, and use the simplified forms of these minuscules. You'll see that your writing takes on an entirely different character compared to the standard minuscule/swash capital combination.

Bobby Holiday

Bobby Holiday

Glorya Phillips

Glorya Phillips

Kathy Goldberg

Kathy Goldberg

The contrast in stroke weight between the capitals written at 30° and the 45° minuscules is more visible in larger writing than small.

30° 45° 30° 45°

Swash capitals are considered flourished letterforms, but there are other possibilities as well. Here are some letters to copy. They were written with a 2 mm nib at 45° and measure about seven pen-widths.

Be sure to maintain the standard letter proportions even when varying the ornamentation or some of the details of the letters.

Some of the loveliest examples of sixteenth century Italic are exemplars of capital letters. During the Renaissance, the scale of these letters was somewhat smaller than our contemporary capitals, often barely higher than the x-height. The Renaissance scribes used either small Roman capitals or more flourished capitals, and wrote them vertically, rather than at a slant.

When used on a page of text, a little extra space was generally left between the capital and the letter following it. Here is an example by Tagliente, which shows the relationship between the capitals and minuscules, and also a reproduction of one of Arrighi's capital letter alphabets.

Tagliente

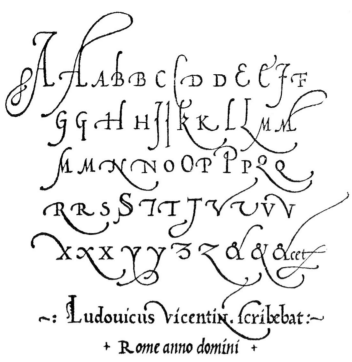

Arrighi

WRITING IN CAPITALS

We occasionally write a word, a line, or even an entire text in capital letters. Simple capitals are generally the best choice for writing Italic in all capitals because they remain legible even on an entire page of writing. If you try to write words using swash or other flourished capitals, you'll see that a combination of decorative letters can be much more difficult to read.

HAPPY NEW YEAR

HAPPY NEW YEAR

Spacing Spacing capitals is more difficult than minuscules because there is more variation in the shape and direction of the strokes. Most Italic minuscules have parallel lines (with a few exceptions: s, v, w, x, and z), whereas the capitals have many different combinations of vertical lines, curves and diagonals.Keep in mind the standard spacing rule: *the space between letters in a word is visually equal to the space inside the letters.* Apply that rule to the negative spaces created when writing in all capitals. The term *visually equal* is particularly significant. Notice how the spaces between these letters are *in balance* with the space inside the letters (the counters) without being *measurably* equal.

To train your eye, here's a good exercise. Choose a long word and write it out. Look at it carefully and ask yourself which letters are too close together or too far apart. (Filling in the negative spaces with a colored pencil can help you make these judgments.) Then rewrite the word directly below your first attempt, trying to correct the spacing. Look at it again and see if it has improved and what further corrections are needed. Try it a third time and it will probably be even better.

ALPHABET

ALPHABET

ALPHABET

Repeat this exercise with several long words. You'll find that with careful observation and self-criticism your spacing will improve.

COPPERPLATE: SIMPLIFIED CAPITALS

The word "simplified," as opposed to "simple," is used here because, unlike Italic, which has a formal alphabet of Simple Capitals, there is no such group of letterforms in Copperplate. We're therefore going to suggest a number of ways to *simplify* your capitals, rather than presenting a formal alphabet.

Most Copperplate capitals are flourished letterforms, characterized by loops and spirals which are generally positioned to the left of the letters, and serve to decorate as well as balance the basic shape of the letters. To simplify the capitals, we're going to remove these decorative strokes without compromising the grace and balance of the letters. The trick is to determine how much can be removed while still retaining the essential Copperplate character of the capitals. The line between "just enough" and "not quite" can be very fine. Let's look at the basic downstroke as an example of how to make this determination.

Decorative Simplified Too Plain

Here are a number of possibilities for simplified capitals. Some of these are more stripped down than others, but all retain their Copperplate form despite the absence of any ornamentation.

Try writing some names beginning with these capitals, followed by minuscules with the simpler forms of the ascender and descender. Compare these with the same names written with flourished capitals and looped ascenders and descenders. You should see quite a contrast.

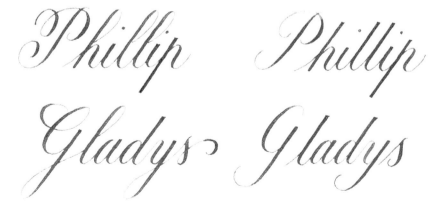

Simplified capitals are recommended over more decorative forms for small writing, but aren't quite as effective when written large.

Franklyn Franklyn

Franklyn Franklyn

COPPERPLATE: FLOURISHED CAPITALS

Copperplate capitals lend themselves to flourishing more than any other alphabet, with the possible exception of the illuminated capitals of the Middle Ages. By making various size loops, curves, and spirals, you can create an almost infinite number of variations without altering the basic letter proportions.

Let's begin with the baseline endings of the downstroke.

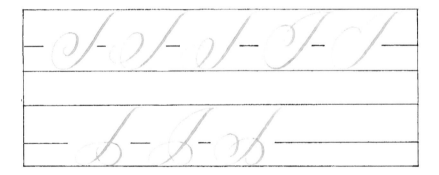

There are also several possibilities for beginning the basic upstroke.

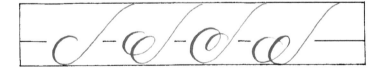

Now let's try some of the strokes and shapes used in the ascender space to the left of the letters. These forms are used as the beginning of the first or second stroke of the capitals; they are not added after the letter is completed.

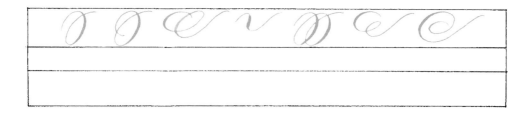

Familiarize yourselves with these forms (by practicing them!) and then try some of the following capital letters. The flourished strokes that appear on some letters can be used on other letters as well. You will see that most of these letters are the same basic form as the Copperplate capitals in Chapter 5.

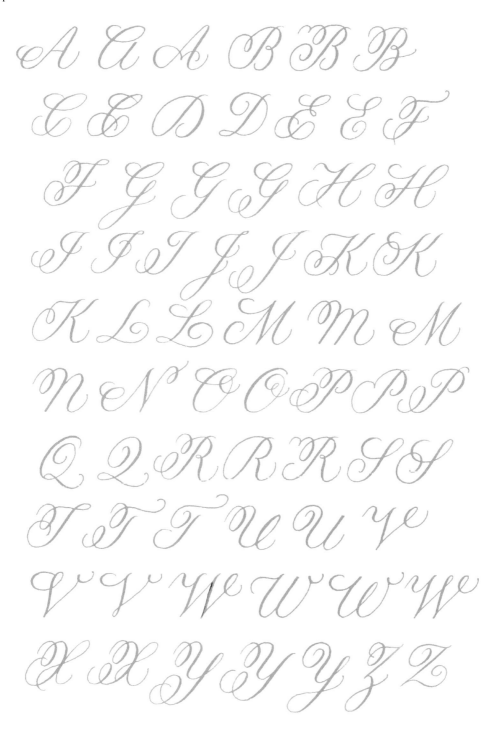

These flourished variations can be used with the standard Copperplate minuscules or with minuscules which have flourished ascenders and descenders.

Elizabeth Elizabeth

Anthony Anthony

You may find that they are a little overwhelming for the simplest minuscule forms, but there are no strict rules about this. The use of numerous very decorative capitals along with simple minuscules on a page of text may not be the best choice, but a single, larger decorative capital followed by some lines of simple Copperplate can be an interesting contrast.

Arma virumque cano, Troiae qui primus ab oris
Italiam fato profugus Lavinaque venit
Litora multum ille et terris iactatus et alto
Vi superum saevae memorem. Iunonis ob iram.

WRITING IN CAPITALS

The simplified capitals are pretty much the *only* acceptable choice for writing Copperplate in all capitals, unless you are designing a logo or monogram using only two or three letters (or if legibility is not essential).

Many calligraphers or calligraphy teachers will tell you that you must never write Copperplate in all capitals, but if you use the simple forms and space them very carefully, the results can be interesting and attractive. It is probably advisable, however, to use this technique for single words rather than for several consecutive words or for a longer text. A line of writing in Copperplate capitals, even the simplest letterforms, can be difficult to read, but a single word can be effective.

Try these two possibilities: either write the letters so that they are completely separate from each other, or allow some of the lines to connect or overlap.

You may need to try this exercise several times before you are satisfied. Always start by working in pencil. Once you have an attractive design, try it in ink.

LEARNING FROM THE PAST

The Universal Penman is an excellent source of Copperplate capitals. Nearly every page includes one or more beautifully embellished letters, and some pages display entire capital letter alphabets. There are other fine books that include reproductions of Copperplate capitals which were written and engraved by the eighteenth and nineteenth century masters.

A very good exercise is to find a book or collect some photocopies and choose some capital letters that you admire. Analyze them one at a time to determine the sequence of strokes, the shape and width of the flourishes, and the relationship between the basic form of the letter and the decorative strokes.

Before trying to copy the letter in ink, work with a pencil. Tracing the letter a few times can help you understand its shape. Use your guide lines to maintain a good letter slant, even when you are working in pencil.

When you write the letter in ink, you will probably find that it is a little more difficult to control the curves and loops, especially on the upstrokes, than it is with a pencil. This is because of the increased resistance (i.e., the paper permits more ease of movement with a pencil than with a pointed pen). Write each letter several times until you are satisfied, before trying another letter.

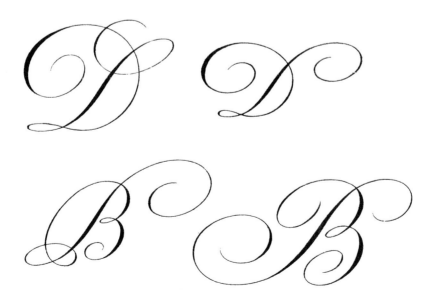

HOMEWORK

There are lots of capital letter projects or assignments to choose from. Here are a few that you can try using Italic or Copperplate.

1. Choose one capital letter and copy as many variations as you can from the various models in this book, in other calligraphy books, and from photocopies of contemporary and historical examples. Try to make one beautiful page showing all the variations that you like of that letter. (It's a very nice idea to make a full-page exemplar for *each* capital letter, but you need quite a lot of time to design 26 pages for Italic and 26 for Copperplate.)

2. This is a variation on the previous assignment. After you have collected as many of your chosen letter as you can, try inventing some new forms. As always, start by working in pencil. Begin by choosing an example that you like from the letters you have copied. Make a small change in one of the flourishes. You can make it rounder, wider, taller, smaller, etc. Than change it again, a little more. Keep adding small incremental variations and you will see your letter evolve.

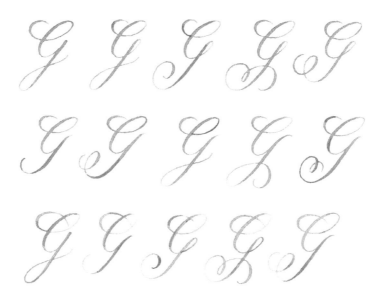

Not every variation will be successful; you will probably like some better than others. After you've written as many new variations on your letter as you can, edit them: circle the good ones or make some notes indicating which you like or dislike. Then rewrite the successful letters in ink. You can, of course, do this with various models of the same letter and alter each of them, or try several entirely different letters.

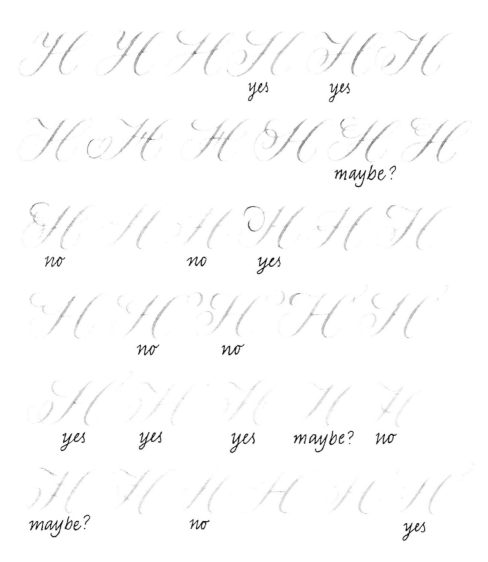

3. You can also try inventing a new alphabet. It might be easiest to do this after you finish #2 (above), because you'll need to start with one letter that you have "created" in the previous assignment. Based on a letter to which you have your personal flourish, try including that flourish in other capital letters, so that you begin to create a family of capital letters.

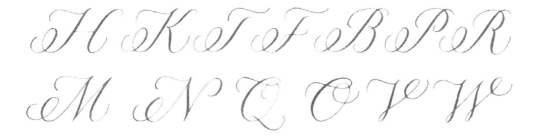

You will no doubt find that there are some letters that can't be coordinated with the others because there is no logical place for your personal flourish. This is inevitably the case in any capital letter alphabet; there are some letters that share the characteristics of weight, slant, and width with the other letters, but not the ornamental elements. Try to write these letters so that they fit visually with the ones you have created.

Chapter 9

Variations in Weight & Proportions

Changes in the weight and proportions of Italic and Copperplate minuscules can dramatically alter the appearance of the letters.

The term *weight* refers to the relationship between the height of the letter and the width of the thick strokes. This is a relationship that can be varied in fairly precise increments in Italic. Changing the weight of Copperplate letters is a less mathematical process, but we'll show you how this can be done as well.

The *proportions* of the letters are the relationships between ascender, x-height, and descender. These proportions are determined mathematically for both Italic and Copperplate. A systematic series of exercises will take you in some new and surprising directions.

Weight and proportions are not mutually exclusive qualities; they both affect the way your calligraphy looks and often the message conveyed by a text. Although changing the weight and proportions of an alphabet can be an exercise or even a game, it is also a valuable skill for the serious calligrapher.

ITALIC: CHANGING THE WEIGHT

The traditional weight of an Italic minuscule is expressed by the equation: x = 5 pen widths. We have all trained our eye to consider letters made according to that formula to be correct. But what happens when we change this rule?

A small increase or decrease in the x-height can change the weight of the minuscule significantly, especially when using a large nib. In the following examples the size of the x-height, ascenders, and descenders will remain equal (to each other), so that a letter with a four pen-width x-height, for example, also has a four pen-width ascender and descender.

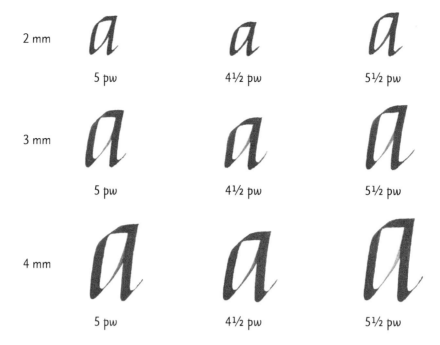

2 mm	5 pw	4½ pw	5½ pw
3 mm	5 pw	4½ pw	5½ pw
4 mm	5 pw	4½ pw	5½ pw

Notice how much more obvious the weight changes are in the examples written with the 4 mm nib than those written with the 2 mm.

If we take this a little further, the weight changes become even more significant. These letters were written with a 3 mm nib.

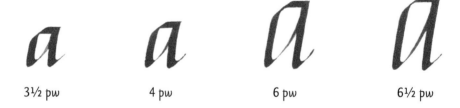

3½ pw	4 pw	6 pw	6½ pw

Using your 3 mm nib, try writing heavier weight Italic using Guide Lines #11 and lighter weight letters on Guide Lines #12. You can draw other lines for either smaller or larger nibs or other weight letters. See how far you can take this in either direction.

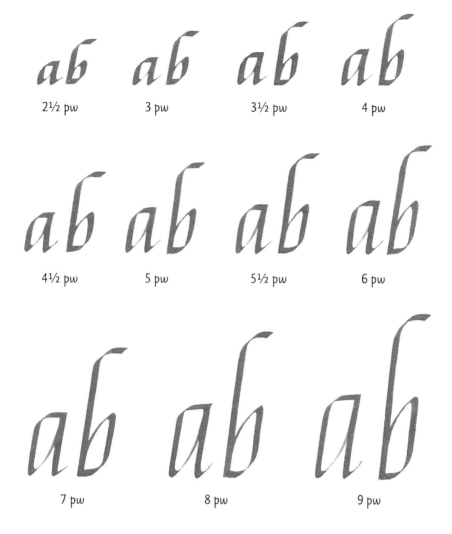

2½ pw 3 pw 3½ pw 4 pw

4½ pw 5 pw 5½ pw 6 pw

7 pw 8 pw 9 pw

ITALIC: CHANGING THE PROPORTIONS

In the previous section, we made some big changes in the appearance of our minuscules while maintaining the 1 : 1 : 1 proportions of the ascender to x-height to descender. Now we'll see what happens when that rule is discarded.

In fact, in Chapter 7 we already bent the rules when we shortened the ascender and descender length in order to simplify our letterforms, and added some extra space to accommodate the more decorative ascenders and descenders.

Without changing the five pen-width x-height, we will now change the size of the ascender and descender spaces gradually, to see what happens when we have significantly less or more space in which to write our letters. The numbers under each example refer to the number of pen widths in the ascender, x-height, and descender.

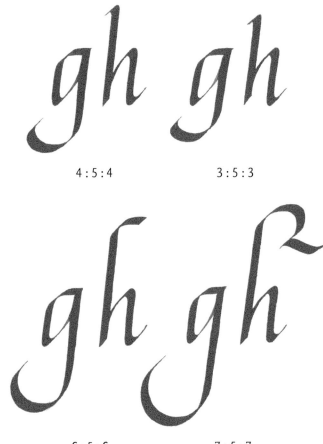

4 : 5 : 4 3 : 5 : 3

6 : 5 : 6 7 : 5 : 7

You can, of course, change the proportions in many other ways. Here are some suggestions:

1. Make the ascenders and descenders unequal, e.g., 4 : 5 : 6, 7 : 5 : 3, etc.

2. Use half pen-widths as increments rather than whole numbers, e.g. 4½ : 5 : 4½, 6½ : 5 : 6½, etc.

3. Make the ascender and descender lengths even more extreme, e.g., 8, 9, or 10 pen-widths.

4. Do any of the above with a different weight x-height.

GUIDE LINES FOR CHANGING ITALIC PROPORTIONS

Rather than including a couple of dozen additional pages of Guide Lines in the back of this book, here's a way you can use the existing lines to experiment with letter proportions.

Make several photocopies of Guide Lines #13. This page is ruled for a 2 mm nib with the line spaces 2 millimeters apart. Thus, five spaces are equal to five pen-widths, four spaces equal four pen-widths, and so on. Use a fine-point marker to darken the lines on your photocopies for the proportions you wish to use, and then use those lines as your baseline, waistline, ascender, and descender lines.

| 4 : 5 : 4 | 6 : 4 : 6 | 5 : 4 : 3 |

If you make a lot of photocopies, you can rule pages for many different letter proportions as well as various letter weights.

Alternatively, you can rule your own guide lines, using either a metric ruler or a paper pen-scale, as shown in Chapter 4. If you choose to do this—and it is a very good idea to learn to draw your own guide lines—do it very carefully so that your line spaces are accurate. This is especially important when measuring half pen widths (e.g., in order to see the difference between a space that measures 4 pen widths and one that is 4½ pen widths).

COPPERPLATE: CHANGING THE WEIGHT

As mentioned at the beginning of this chapter, the process of changing the weight of Copperplate letters is less precise than it is for Italic. Since the weight of a Copperplate letter is a function of pressure on the nib, you can make heavier weight letters by increasing the pressure on the down-stroke without increasing the height of the letter. To make lighter-weight letters, reduce the pressure on the nib without decreasing the height of the letter. Thus, you can make letters of the same height and different weights.

This process obviously takes a good deal of practice and concentration, especially once we are accustomed to putting a consistent amount of pressure on our nibs.

Using a more or less flexible nib can facilitate this and can help avoid the additional strain on our wrists that can be caused by pressing excessively on the nib. A less flexible nib, as we know, will

give us a lighter weight stroke with the same amount of pressure that will produce a heavier stroke using a more flexible nib. (This was discussed in Chapter 6.)

Although it is a good exercise to experiment with different weight Copperplate letters, it is perhaps more interesting and certainly easier to change the letter proportions.

COPPERPLATE: CHANGING THE PROPORTIONS

The system for changing the proportions of Copperplate minuscules is very similar to the one we use for Italic. In both cases, we draw lines to make larger and smaller spaces in which to write our ascenders and descenders. The main difference is that for Italic, these spaces are measured in nib-widths; for Copperplate, they are based solely on the measurement of the x-height.

According to classical proportions, the ascenders and descenders are 1½ times the x-height, which can be expressed as 1½ : 1 : 1½ (or 3 : 2 : 3). If the x-height is ¼", the ascenders and descenders are ⅜". If we change these proportions to 2 : 1 : 2, and our x-height remains ¼", our ascenders and descenders will measure ½". If we want the proportions to be 1 : 1 : 1, all three spaces will measure ¼".

balancing

3 : 2 : 3

balancing *balancing*

2 : 1 : 2

balancing

1 : 1 : 1

It is important to remember to choose appropriate letterforms for the lengths of the ascender and descender spaces. A more flourished form fits better in a larger space, a simpler form in a reduced space. A good guideline for this is: When your ascender and descender spaces are 1½ times the x-height or more, use the more decorative forms. When the ascender and descender spaces are equal to or less than the x-height, the simpler forms are a better choice.

Yes Yes No

You can also try other proportions, such as 2 : 1 : 1 or 1 : 1 : 2, or more extreme ones like 4 : 1 : 3 or 3 : 1 : 2.

2 : 1 : 1 1 : 1 : 2

4 : 1 : 3 3 : 1 : 2

An x-height that is bigger than either or both the ascenders and descenders can make an interesting alphabet as well.

a b c d e f g h *thoughtfully*

1 : 2 : 1

a b c d e f g h *thoughtfully*

3 : 2 : 1

a b c d e f g h *thoughtfully*

1 : 2 : 3

GUIDE LINES FOR CHANGING COPPERPLATE PROPORTIONS

If you wish to draw your own guide lines for variations on the Copperplate proportions, here's a suggestion. Rather than measuring in inches, use the metric system. Metric, which is based on a decimal system, is much easier to work with.

One-half centimeter (5 millimeters), which is a little smaller than ¼ inch, is the size of the x-height on Guide Lines #7. If you make that your x-height, it is very easy to rule lines for spaces that are multiples of the x-height. With proportions of 2 : 1 : 2, for example, your ascender space will measure 1 cm, the x-height ½ cm (5 mm), and the descender space 1 cm (or 1 cm, 5 mm, and 1 cm). If the proportions are 3 : 2 : 1, your measurements would be 1½ cm (15 mm), 1 cm and ½ cm (5 mm).

Guide Lines #14 is ruled in ½ centimeter widths. You can use these guide lines for Copperplate in the same way that you use Guide Lines #13 for Italic, by making multiple photocopies of the page and then darkening the horizontal lines you select for your ascender, x-height, and descender lengths. If you want to use 3 : 1 : 3 proportions, for example, or 1 : 2 : 1, this is what your page would look like:

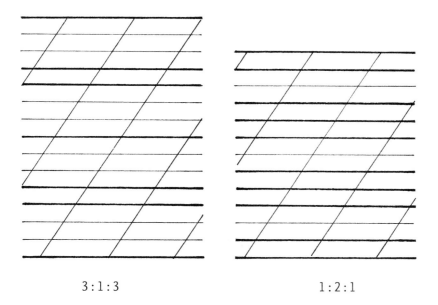

3:1:3 1:2:1

Using either system—by drawing lines with a metric ruler or using the printed guide lines—try some "Extreme Copperplate." Choose some proportions that you have never tried, perhaps ones that seem a bit absurd, and write a few lines of text. You may find that you are inventing a new alphabet!

pineapple

7:3:1

cherry cake

1½:2:6

blueberry

2:5:3

HOMEWORK

Changing the weight and/or proportions of your Italic and Copperplate minuscules can take you in many new directions. Here are some exercises that you can try:

1. Choose two words that have ascenders and descenders, perhaps a person's name or the name of a shop or a business. Without changing the weight, write the name using as many different proportions as you can. Keep the capitals within a normal size range. Some suggested names with ascenders and descenders include: Cyndy's Bakery, Geoffrey Nathan, Bobby Tyler. Here's an example:

Jewelry Shop *Jewelry Shop*

Jewelry Shop *Jewelry Shop*

Jewelry Shop *Jewelry Shop*

Jewelry Shop *Jewelry Shop*

2. Write a short text in which you emphasize one or more words by changing the weight. Do this exercise in Italic only.

*It is better to have **loved** and **lost** than never to have loved at all.*

3. By means of variation in weight and/or proportion, try inventing an unusual alphabet. The alphabets illustrated here have proportions of 3 : 3 : 3, written with a 3 mm nib, and 2½ : 10 : 10, written with a 1 mm nib.

abcdefghi
jklmnopqr
stuvwxyz

3 : 3 : 3

abcdefghijklm
nopqrstuvwxyz

2½ : 10 : 10

Chapter 10

Flourishing

To students of calligraphy, *flourishing* is a magnetic, almost irresistible force. Beginners often confess that the reason they study calligraphy is to be able to embellish their writing with loops, swirls, and cartouches. And why not? One of the wonders of the pen is its ability (in the right hands) to create these magical flights of fancy.

Flourishing, like letterforms, can be learned through observation, exercise and practice. And, like the study of basic calligraphy, there are a number of characteristics and rules that are common to both Italic and Copperplate, and some that are specific to one alphabet or the other.

GENERAL CHARACTERISTICS OF FLOURISHING

A calligraphic flourish is simply — or not so simply — a decoration. It can be anything from a single stroke or an extended line to a fully embellished border. More often than not, flourishes are made with the same pen that is used for writing, often as part of the beginning or ending stroke of a letter.

Here are a few points to remember about what flourishes are and how they are used:

1. Flourishes are extensions of pen forms, strokes that are longer, taller, or wider than the basic letter shapes.

2. Flourishes are mostly positioned along planes that are parallel to the horizontal, rather than running uphill or downhill.

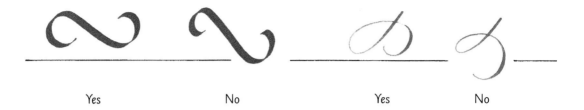

Yes No Yes No

3. Most flourishes have strong straight lines with curved endings, rather than a succession of curves.

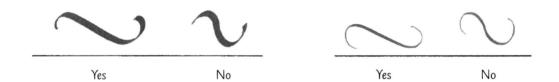

Yes No Yes No

4. Flourishes need to be in balance with the word or words on the page and with each other.

5. Flourishes should be used with care and aesthetic judgment. Try not to overdo your use of flourishes. Often a single well-drawn flourish is a better choice than a page of curlicues.

 Here are some suggestions that may help you learn how to make these decorative forms:

1. Start by making flourished strokes with pencils or markers and correct or fine-tune them before using pen and ink.

2. Collect examples from historical and contemporary calligraphers and study them.

3. Be aware of the negative space and the space created when lines intersect.

Negative Space

4. Allow enough space for longer ascenders and descenders and wider capitals so your page won't appear too crowded.

5. Flourishes are often made in a number of separate strokes rather than with continuous pen movement. Don't try to make an elaborate flourish without lifting your pen.

In the pages that follow, we'll see how these rules and suggestions apply to Italic and Copperplate.

ITALIC MINUSCULES

There are a number of fairly simple ways to flourish Italic minuscules. Decorative strokes can be added to the ascenders and descenders; they can appear as extensions of letters, at the ends of words or lines of writing, and, occasionally, letters can be combined or interwoven by means of additional strokes.

Ascender Flourishes Any letter with an ascender can be decorated. Do this in two strokes, starting with the downstroke. Write the entire letter (and sometimes finish the word or line of writing) before adding the flourish.

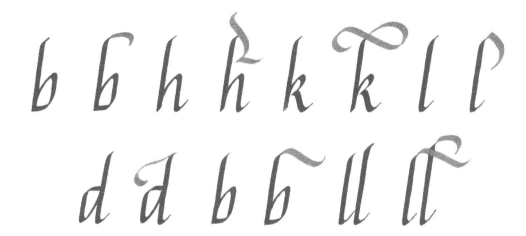

Notice that all these decorative ascenders have dominant straight lines as explained on the previous page.

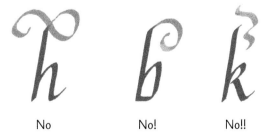

No No! No!!

Ascenders can be further embellished by making the flourishes wider or adding extra strokes.

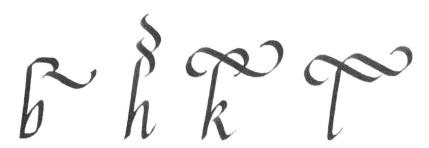

Descender Flourishes These are either loops or extended curves and strokes, or a combination of these forms. Like the ascenders, decorative descenders require more space to the left and/or the right than the standard descender forms.

Extensions We can flourish the last letter in a word by extending part of the letter or by adding an additional stroke.

These extended forms should be used judiciously (i.e., never in the middle of a sentence and *never* in the middle of a word).

This is not so easy to read
and isn't very attractive.

There are some letters that can be combined to make new forms. The combinations of s and c with t, and p, as well as with some ascender letters, come from Renaissance examples.

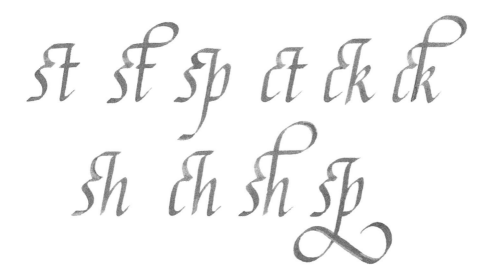

A combination of two or more ascender letters is a particularly attractive way to flourish your Italic.

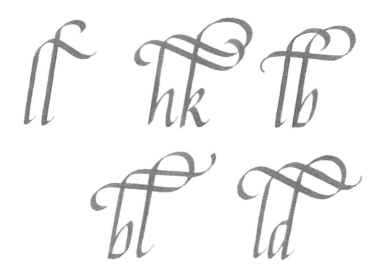

ITALIC CAPITALS

Some beautiful examples of flourished Italic capitals are found in the pages of the sixteenth century writing books of Arrighi, Palatino, and Tagliente, as well as in Georg Bocskay's astonishing *Mira Calligraphia*.

We've already looked at two pages from Arrighi's *Operina* (see pages 5 and 71); here are some other historical models to enjoy and borrow from:

CON GRATIE. ET PRIVILEGI.

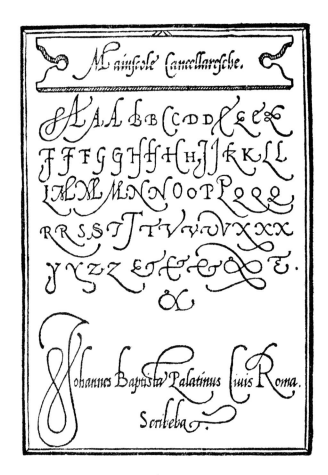

Palatino

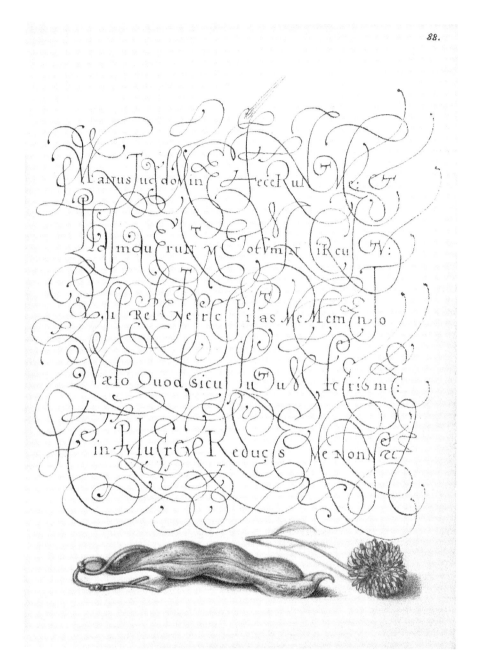

Joris Hoefnagel, *Kidney Bean and English Daisy* from *Mira Calligraphiae Monumenta*, ca. 1591–1596. Watercolors, gold and silver paint, and ink on parchment and paper bound between pasteboard covered with red morocco. 16.7 x 12.4 cm (16⁹⁄₁₆ x 4⅞ in.) The J. Paul Getty Museum, Los Angeles

You'll notice that most of these capital letters are written vertically. We can adapt these forms to contemporary Italic by slanting them and also by choosing capitals that seem most appropriate to or harmonious with our own letterforms.

It is a good idea to reserve the use of enlarged or ultra-flourished capitals for a place of importance in your writing, rather than scattering them indiscriminately throughout a page of calligraphy.

LEARNING FROM THE PAST

In addition to collecting and copying historical models, we can study these examples to see how they were formed. We can, moreover, develop our own capital letters based on flourished capitals of the Renaissance scribes. Here's how to proceed.

Using a copy machine or a computer, enlarge a reproduction of some Renaissance capitals in order to see more clearly how the letters are structured. Find a nib that gives you a stroke equal to the weight of the thick strokes of the letter you are studying, and then see if you can determine the height of the letter based on pen widths. This example is from Arrighi's *Operina*.

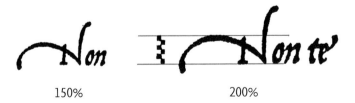

150% 200%

Be aware that this will be approximate at best, because there is always some distortion resulting from photocopying or enlarging any artwork.

Analyze each letter to determine the number and sequence of strokes. It might be a good idea to trace it a few times in order to become familiar with the form.

Once you can write the letter more or less as it was originally designed, try altering it slightly, slant it at 7°, and increase or decrease some of the flourished strokes. You can even add or eliminate some of the decorative embellishments.

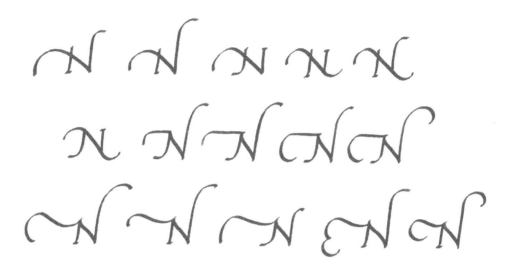

This is not unlike the system explained in Chapter 8 for inventing new capital letters.

COPPERPLATE FLOURISHING: BASIC SHAPES

Copperplate flourishing, which initially appears to be very complicated, can be broken down into a few component shapes. We'll start by drawing these forms with a pencil before either combining them with letters or working with pen and ink.

The essential form of most Copperplate letters and flourishes is an *oval* or *ellipse*. This is an o-form that consists of two sets of opposite curves. It can vary from quite narrow to almost round, but it is never absolutely circular.

Opposite Curves

The *loop* and the *spiral*—which are also based on the oval—should be familiar from having practiced the Copperplate capitals. They are used in various sizes and directions (i.e., clockwise and counterclockwise, slanting to the left and right).

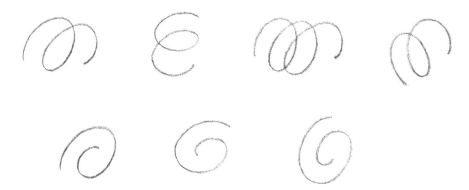

The *s-curve* consists of a straight central line with curves at both ends going in opposite directions. It sometimes doubles back on itself to form a *figure 8*.

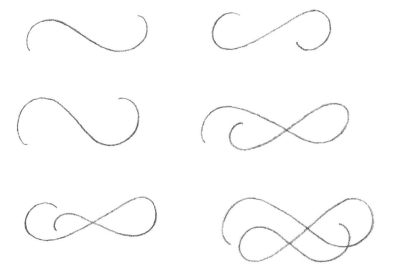

These forms can be combined in various ways, for example, spirals and loops, s-curves and spirals, s-curves and loops, double spirals, and multiple loops.

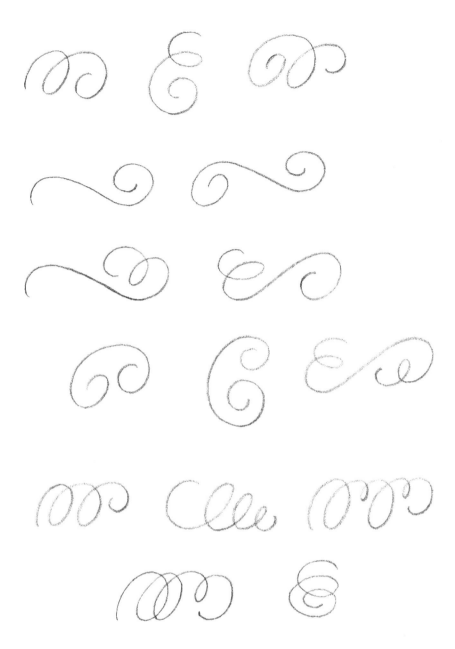

When drawing these shapes in pencil, limit the size to about 1″ to 1½″. Keep in mind the limitations of the Copperplate nib; it is *much* easier to draw a larger form with a pencil than with a pointed nib. Make your pencil drawings fairly lightly, without pressing too hard or using too black a pencil.

Choose some of your more successful pencil forms and use a Copperplate pen to write directly over the pencil lines. Turn your paper in a comfortable position so that the longest or most important lines of your flourish will be written as downstrokes, and will therefore be thick lines. These will be the dominant strokes.

You can erase your pencil lines after the ink is thoroughly dry. Erase carefully using a kneaded eraser; don't press too hard or rub directly over the ink.

COPPERPLATE MINUSCULES

These letters can be flourished much the same way as the Italic minuscules on the ascenders and descenders by extending the endings of letters, and by combining some letters. The results, however, are quite different from those of flourished Italic.

Ascender Flourishes Several examples are shown on page 57 in Chapter 7. Be sure to remember that the ascender loop is usually wider in a flourished letter and starts above the waist line.

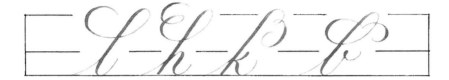

These loops and spirals can be bigger or smaller, but never shorter than the standard ascender length.

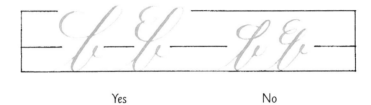

Yes No

Descender Flourishes These flourishes consist of loops, spirals, extended lines, and sometimes s-curves. Allow enough space to the left and right to accommodate these forms.

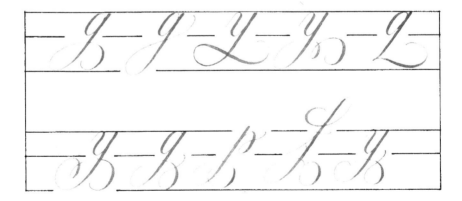

Extensions Like Italic, the last letter of a word can be flourished, but only if it's at the end of a line or, occasionally, at the end of a sentence. These flourishes often take the form of extended horizontal strokes, some of which are simple s-curves. Others are s-curves combined with loops and spirals.

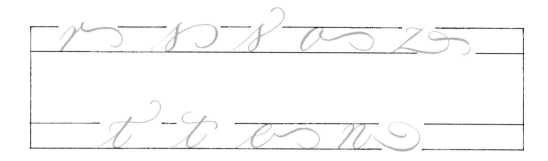

Notice that some of these examples have horizontal thick strokes. This is not the natural position for the pressure stroke if your paper is held in a normal position. In order to hold the pen comfortably and still manage to emphasize these horizontal lines (by making them thicker), you can follow the procedure explained on page 103, when we discussed drawing and inking the basic shapes of Copperplate flourishes. The easiest way to add these extensions is to draw them lightly in pencil and turn the paper sideways to ink them in.

Combinations Many letters can be combined or joined by means of extended lines and loops. Here are a few to copy. There are many other possibilities as well.

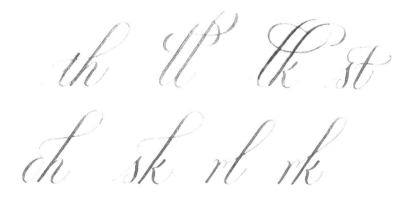

As always, a pencil is a good tool for drawing or designing minuscule combinations, especially if there are several letters with crossing strokes.

COPPERPLATE CAPITALS

In Chapter 8, we discussed some of the possibilities for flourished Copperplate capitals, and demonstrated how you can invent your own variations.

Standard flourished Copperplate capitals employ many of the loops and spirals that we see on the minuscules. We have already demonstrated how the basic downstroke of the capitals, which is an s-curve, can be combined with a variety of beginning and ending strokes to create a wide range of letterforms, from the simple to the ultra-ornate.

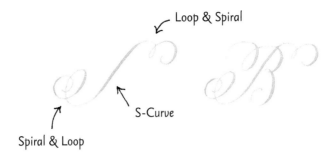

Loop & Spiral

S-Curve

Spiral & Loop

An abundance of flourished capitals can be found in eighteenth century engraved Copperplate, often in page headings or titles. Look for your favorite forms and analyze them to locate the basic elements: ovals, loops, spirals, s-curves. Try tracing and drawing these letters so that you can incorporate your own variations in your artwork.

WHEN AND WHERE TO FLOURISH

This applies to Copperplate and Italic alike.

Flourishing a word, a headline, or a full-length text can add enormously to the effect of your calligraphy. In this chapter, we have mentioned a few places where a flourish may be a good choice, but now let's consider *why* we flourish, as well as *when* and *where*. We should also bear in mind that flourishing may not always be a good idea.

Here is a basic check list of positions for one or more flourished strokes. The examples shown were written in Copperplate, but Italic can be used in a similar fashion.

1. at the beginning and/or ending of capital letters

2. at the top of minuscule ascenders and the bottom of descenders

3. at the end of a word

4. at the end of a line

5. on the top line of a text (ascenders)

6. on the bottom line of a text (descenders)

7. in the title of a text

8. as a border design

1 2

goodbye

3

The noble Duke of York

He had ten thousand men

4

I will not cease from mental fight,
Nor shall my sword sleep in my hand
Till we have built Jerusalem
In England's green and pleasant land.

5, 6

Title of Work

7

8

Needless to say, it may be inadvisable to do all of the above on a single page of text. Knowing how much is enough is not always easy and there are really no simple rules to follow. But here are a few questions you can ask yourself to help decide how much to flourish.

1. What is the mood of the text? If it is cheerful, romantic, or poetic, a few (or more) flourishes can enhance the mood. If the text is sober, serious, or negative, little or no flourishing may be better. But there are always exceptions. Certain documents, such as awards and diplomas, which are certainly serious, are traditionally enhanced by flourishing. So we must ask ourselves not only what we are writing, but what the calligraphy will be used for.

2. What is the form or layout of the page? Or, from a practical point of view, is there any room on the page for flourishes? In addition to decorating a piece of writing, flourishes are used for balance. Once you have determined that flourishing is appropriate for your word, line, or text, you must consider what happens to the balance of the page when flourishes are added. Here are some good choices and bad choices, using Copperplate for our examples. This is applicable to flourished Italic as well.

Since there's no help
come let us kiss and part,
Nay I have done
you get no more of me...

Good Choices

Since there's no help
 come let us kiss and part—
Nay I have done
 you get no more of me...

Bad Choices

3. How much is too much? This, too, depends on the nature of the text, but it also depends on your own taste and level of skill. A single beautiful flourish can be just the right amount of decoration if it is positioned well on a page. For example, a single, enlarged flourished capital on a page of simple writing is often a good choice, as shown in Chapter 8, on page 76. Similarly, the top and/or bottom line of a symmetrical invitation can be decorated by a flourished capital or ascender (top line) or descender (bottom line).

You are cordially invited
to attend a reception
in honor of
Mr. Robert Browning
Saturday, March 31
at 4:00 PM
at Carnegie Hall
New York City

Sometimes more than one flourish is necessary or desirable on a piece of calligraphy, but it is also possible to go too far. If your writing—word, line, page—looks too crowded, confused, and overly fussy, or if excess flourishes distort the meaning of the text, you may have to rethink your flourishing decisions. This is especially true if the flourishes make the text difficult or impossible to read.

Furthermore, you should take into consideration your level of skill and experience. If you are a beginner at flourishing and are trying out all the possibilities in order to learn the process, by all means flourish as much as you like! If, however, you are relatively inexperienced and want to include some flourishes on an exhibition piece or a paid commission, it may be advisable to limit yourself to a few well designed strokes.

HOMEWORK

Use Copperplate for the first assignment. The other assignments can be done in either Copperplate or Italic.

1. In eighteenth century Copperplate, flourishes were often used to "justify" the right margin, i.e., to make all the lines of writing the same length.

Seek you to train your fav'rite Boy?
Each Caution, ev'ry Care employ;
And ere you venture to confide,
Let his Preceptor's heart be try'd;
Weigh well his manners, life, & Scope,
On these depends thy future hope.

W. Clark, The Universal Penman

Choose a text of four to six lines and write it in a block format, with all the lines starting under each other at the left margin, i.e. flush left. Add flourished extensions at the end of each line, so that all the lines end at the same place. (Look at historical models for inspiration.) Draw the extensions first lightly in pencil; write them in ink after you are satisfied with your drawings. Remember to turn your paper sideways before doing the extensions in ink, in order to allow the horizontal strokes to be the weighted lines. After the ink is completely dry, erase the pencil lines.

2. Write some words with three ascenders, such as ball, fall, draft, chilly, laughed, half. Try to flourish the ascenders in a variety of ways including flourishes that intersect each other.

3. Choose a text of 20 to 30 words, starting with a capital letter. Find a historical model (either Italic or Copperplate) with flourishes that you'd like to borrow. Analyze the letter by tracing or drawing the flourishes, using an enlarged copy if the model is too small. Copy the letter carefully and then try altering it slightly to make it your own. (This is, in fact, an almost inevitable result of trying to copy something exactly.)

 Use this letter as the decorative element in your text. Write the rest of the text simply, so that it doesn't conflict with the dominant capital letter. The first letter of the text—the letter you are working with—should serve as a contrast to the text, both in size and in ornamentation.

4. Work from a Copperplate historical model. Choose a well-designed title or border from one of your favorite sources. Using tracing paper and a pencil, isolate the various elements that comprise the flourishes. You will find that even a complicated design consists of simple elements, carefully combined with balanced positive and negative spaces.

Joseph Champion, The Universal Penman

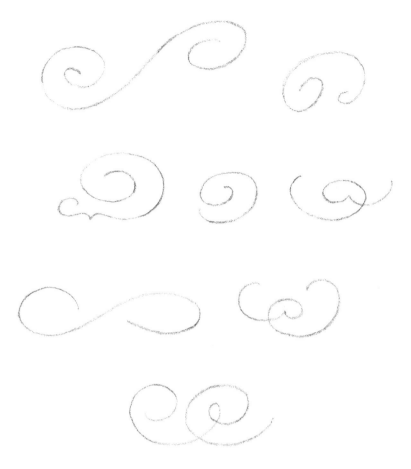

5. Decorate a name, a title, or a word or two with a flourished border. It is probably best to start with a single name or perhaps an initial and last name. For this assignment, you will need to find names or words with ascenders and descenders. Here are some suggestions: Hello, Thank You, Calligraphy, Happy Holidays, Happy Birthday. (A flourished word or two can make a beautiful greeting card.)

Here's a step-by-step method for decorating the words Happy Birthday:

a. Write the words in pencil (in Italic or Copperplate) in a very simple form without embellishing the ascenders or descenders.

b. Look at what you have written and consider where flourishes can be added. Top? Bottom? Left? Right? Capitals?

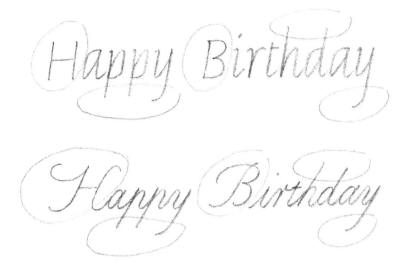

c. Continue using your pencil and draw a few large curves in the places where you want your flourishes, restricting yourself to simple forms. Make sure your design is balanced along a central axis. To do this, your curves should be left and right or centered, but not all on one side.

d. Add some smaller curves, loops or spirals to correct imbalances or enhance the design. Use your eraser and rework as necessary.

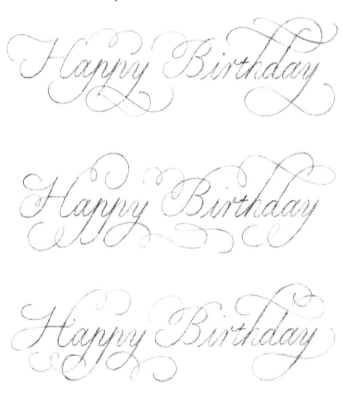

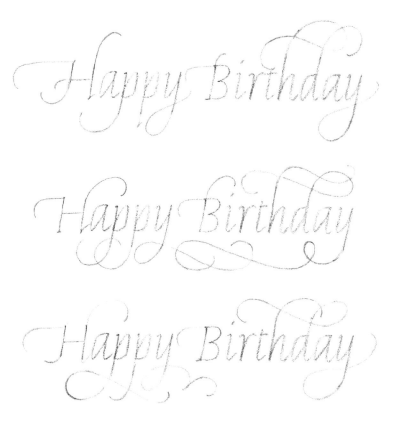

e. Look at your drawing to see if it's graceful and balanced. One way to determine if your design is balanced is to draw a rectangle around it. (You can also draw the rectangle on a piece of tracing paper and lay it over your design.) Here is an example that is definitely off-balance!

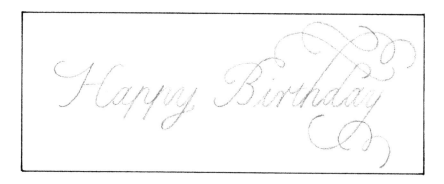

If you are not satisfied with your design, you can start again, perhaps by writing the undecorated word (step #1) a few more times to give yourself several options to work with, or by placing a piece of tracing paper over your design and correcting your curves and loops in pencil.

f. Once you have an acceptable design, try doing it in ink. First write the word without flourishes (in ink), and then lightly pencil in some flourishes. To do the flourishes in ink (for Copperplate only), turn the paper as necessary so the longer strokes are the thick strokes.

Happy Birthday

Happy Birthday

Remember that you do not need to make a complicated flourish in one movement; you can start and stop in order to reposition your pen or your hand. But never stop in the middle of a stroke, only at a point where two strokes cross.

Stop here.

Don't stop here.

This assignment is difficult. You will probably find that flourishes which are easy to draw with a pencil don't come out quite the same in ink. You may need to do this exercise a second or third time with a few less flourishes! One beautiful flourish is better than a page full of poorly constructed whirls and swirls.

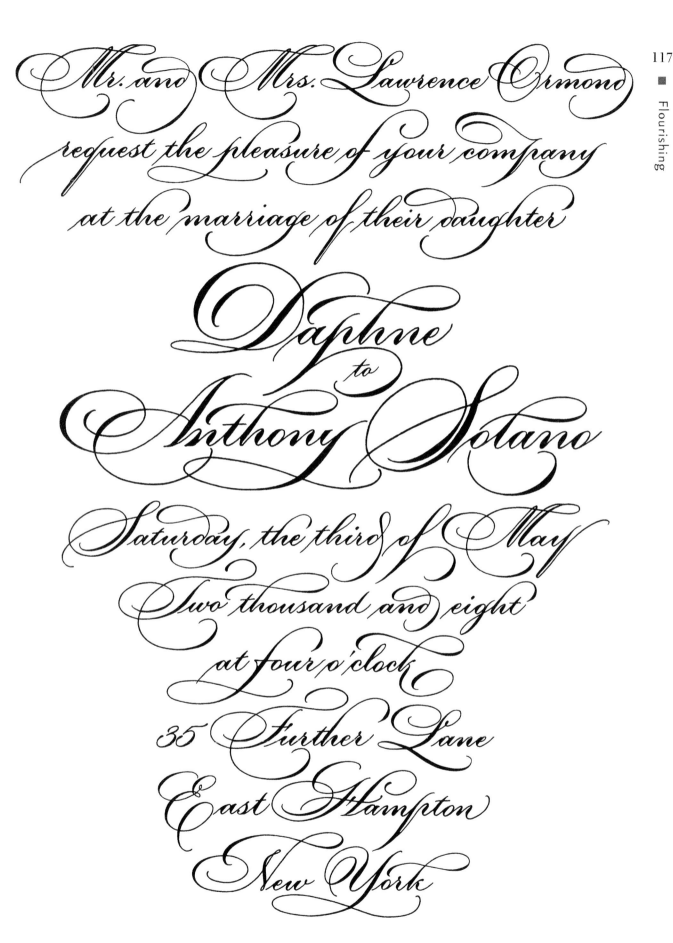

Mr. and Mrs. Lawrence Ormond

request the pleasure of your company

at the marriage of their daughter

Daphne

to

Anthony Solano

Saturday, the third of May

Two thousand and eight

at four o'clock

35 Further Lane

East Hampton

New York

Caroline Paget Leake

Calligraphic Handwriting

The letterforms of Italic and Copperplate can be used to develop a personal calligraphic handwriting. In the past, penmanship instruction was based on both of these alphabets.

Penmanship as an elementary school subject is, unfortunately, rarely taught nowadays. Children learn to write, of course, but more often than not the letters are "stick and ball" forms, casually taught and even more casually practiced.

But despite the sad lack of handwriting instruction in public schools, and indeed the disastrous look of most handwriting, we can still use our Italic and Copperplate as the basis of a personal calligraphic script. It is, however, important to note that our handwriting as adults (such as it is) was formed in childhood and is very hard to transform completely. A calligraphic handwriting is, in most cases, an *additional* way to write, rather than a replacement for our "normal" writing.

To turn our formal calligraphy into a less formal script, we use simplified forms of the letters which can be joined to make words. The number of pen lifts is reduced so that writing can be, to some extent, continuous.

In the pages that follow, we will be concentrating on the minuscules. Once you are able to write an informal hand, we suggest that you choose simple, unadorned capitals that harmonize well with the lower-case letters.

ITALIC HANDWRITING

There are certain standard techniques for transforming formal Italic into an informal script. In fact, even in the Renaissance, Italic was generally divided into two styles: Chancellaresca Formata (formal) and Chancellaresca Cursiva (cursive, or informal).

For a modern cursive Italic, we're going to make some letter changes which will enable us to join the letters to each other.

1. Remove entrance strokes, except for the first letter of a word.

2. Shorten and simplify ascenders and descenders.

3. Add exit strokes to some letters.

$$\sigma \quad \mathcal{S} \quad \mathcal{S} \quad \nu \quad w$$

A monoline Italic, incorporating these simplications, can be written with an ordinary pen (ball point, rolling writer, marker) or a pencil.

a b c d e f g h i i j j

k l m m n n o o p p

q r r s s t u u v v

w w w x y y z

There are a number of small alterations in technique that make cursive Italic flow easily, so that the letters connect with each other without too many pen lifts.

1. Letters ending with exit strokes join to letters with entrance strokes without stopping.

tij sun minimum

2. The a-group letters (a, c, d, g, q, but not u and y), which normally start with a small stroke to the right followed by an overlap and counter-clockwise stroke, can be done in a single counter-clockwise movement. The d, which is normally a two-stroke letter, can be written in either one or two strokes, depending on the type of pen you are using and the size of the writing.

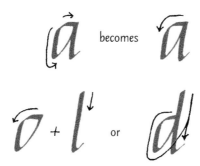

becomes

or

If one of these letters follows a letter with an exit stroke, you will need to finish the first letter, move your pen to where the a-group letter begins, and attach the second letter to the exit stroke of the first letter. (You cannot do this without stopping.)

not

3. Certain letters without exit strokes cannot be joined without lifting the pen. These letters are the b, g, j, p, q, and y. If the letter that follows one of these letters begins with an entrance stroke, this stroke can be used as a ligature.

bn qu pr

If these letters are followed by a letter without an entrance stroke, the two letters generally cannot be joined. Try to pay extra attention to the spacing.

pe bo gh

4. Exit strokes can be added to the o, v, and w, which can then serve as ligatures. These variations are shown in the monoline alphabet on page 120.

ot vi wo

5. There are a few special cases. To join into an e, you can either make the standard two-stroke e, or change the form slightly and make the e in one stroke, starting in the middle. If you make a two-stroke e, the next letter can be connected from the middle (where the letter ends); if you make a one-stroke e, the letter than follows can be joined from the bottom.

ι + ⌐ = e or *e*

n + ⌐ = ne or *ne*

ι + n = en or *en*

Joining letters from the f, t, r, and s also involves some small variations on the standard forms.

fr fe tr ti

ri re rt st si st

Italic handwriting can take on a personal character when you decide which of these ligatures are comfortable—visually and physically—and which you prefer to ignore. Furthermore, Italic handwriting can be taller or shorter, wider or narrower than formal Italic, depending on your taste or even your mood. These examples were all written with the same nib:

Much have I travell'd

in the realms of gold

And many goodly states

and kingdoms seen

Round many western islands

have I been ...

OTHER TOOLS FOR ITALIC HANDWRITING

Italic handwriting lends itself to a wide range of writing tools, including, but not limited to, ball-point pens, fountain pens, gel pens, and even crayons. It can be effectively written with a variety of calligraphic tools as well, such as chisel-edged markers, standard broad-edged dip pens, broad-edged fountain pens, and even Copperplate pens. You can even decorate a cake with icing lettering, using Italic handwriting (although you have to be a pretty good cake decorator to do this).

As an experiment, and for the fun of it, assemble as many different writing tools as you can and some sheets of ruled paper, such as loose-leaf paper or a legal pad. Write a sentence or two with each pen or writing tool, varying the height of the letters as seems appropriate for each tool.

Calligraphy Marker

wide marker

Sparkly Gel Pen

Pointed Marker

Flourescent Pen

Colored Pencil

Very Fine Point Marker

Flexible Pointed Nib

Turning Copperplate calligraphy into a personal script also involves changing a few rules and varying some letterforms.

Like Italic, Copperplate handwriting is easier to practice with tools other than calligraphy nibs. This is particularly true for Copperplate because the pointed Copperplate nibs work best when we write slowly and meticulously; an informal Copperplate handwriting needs to have a different, somewhat faster, rhythm.

One of the strict rules of formal Copperplate (written with a dip pen) is that almost every letter is made in two or more strokes with pauses or full stops between the strokes. Words are constructed similarly, with numerous stops and pen lifts.

To turn Copperplate into a cursive script, we abandon this rule, at least to some extent, although it remains advisable not to write too quickly. If you write your Copperplate letters with a pencil, a pointed marker, or a gel pen, you will find that most letters can be made in a single stroke.

Let's start by writing a monoline Copperplate alphabet without connecting the letters. Write slowly, paying attention to the o-shape, the 55° slant, and the proportions of the letters. This example was written with a gel pen.

You'll notice that the forms are no longer as precise as pen-made forms, but they still retain their Copperplate character.

These monoline Copperplate letters can be joined to each other, as are normal, pen-written Copperplate letters, but with far fewer pen lifts. You will need to pause or stop after certain letters, but the feeling of a cursive handwriting should be easy to achieve.

How sweet the moonlight

sleeps upon this bank

How sweet the moonlight

sleeps upon this bank

How sweet the moonlight

sleeps upon this bank

Like Italic, Copperplate handwriting can be a little wider or narrower than the standard alphabet, and can also be spaced somewhat further apart to create a script to your liking.

handwriting

handwriting

handwriting

handwriting

handwriting

Many of the writing tools suggested for Italic handwriting can also be used for Copperplate, with the exception of broad-edged pens and chisel-edged markers. Experiment to see which ones work best for you.

Pointed marker

Rolling ball

Colored pencil

Gel pen

Ultra-fine marker

Ball point pen

A BRIEF WORD ABOUT SPENCERIAN

Spencerian, a form of nineteenth-century American handwriting, has certain characteristics that are similar to monoline Copperplate. The letters are joined by relatively wide, slightly angular ligatures. Certain strokes in Spencerian are made with heavy pressure on the nib, but not in the same system as Copperplate (i.e., not every downstroke in Spencerian is a pressure stroke). The capitals, in particular, are characterized by heavily weighted downstrokes, in striking contrast to the lighter weight minuscules. This creates a lively pattern of light and dark, with an elegance and beauty of its own.

Spencerian Alphabet

Aa Bb Cc Nd Ee

Ff Gg Hh Ii Jj

Kk Ll Mm Nn Oo

Pp Qq Rr Ss Tt

Uu Vv Ww Xx Yy Zz

Michael Sull

Only in Books has Mankind known Love, Perfect Truth and Beauty.

—George Bernard Shaw

Michael Sull

Write a letter. Choose a non-calligraphic tool that you enjoy writing with. Working on lined paper, write an informal note to a friend. Try writing it several ways, first in Italic, then in Copperplate.

Here's an example, but you should invent your own text.

> Dear Jeffrey,
> When are you arriving in Paris? I can't wait to see you! Don't forget the bagels.
> Love from us both

> Dear Laurent,
> What's new? Are you interested in going to the movies next weekend? Give me a call and we'll make plans.
> Yours, Dolores

Notice that not every letter that *can* be connected to the letter that follows is, in fact, connected. Some joins are more fluid than others, and we may choose to do some and not others. In addition, it is often necessary to pause or lift our pens to reposition our hand.

PART 3

Design & Projects

Texture

Experienced calligraphers are sometimes surprised when the word *texture* is used in the same sentence as *Italic* or *Copperplate*. Texture, which brings to mind weaving and textile, is more often associated with the closely written Gothic scripts of the Middle Ages.

But using Italic or Copperplate to create texture is not only possible, it is an interesting and beautiful use of these alphabets.

Texture in calligraphy is created by the relationship between lines of writing and the white space, also known as *interlinear space*, between them. In some cases, more often with Italic than Copperplate, the weight of the letters is also a factor.

Texture doesn't have to be dense; a page of writing can have an open, "loosely woven" texture. As the balance between black and white (the lines of calligraphy and the space between the lines) changes, the effect of the writing varies as well. With any style of calligraphy or, indeed, typography, the woven effect of a page of writing is increased by putting the lines closer together and decreased by moving them apart.

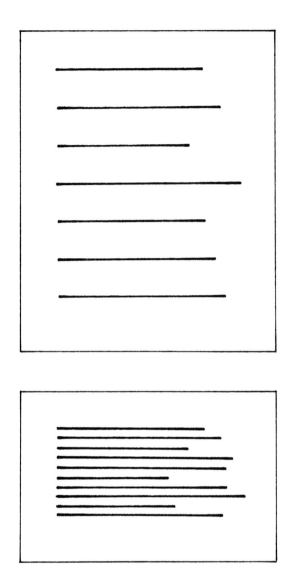

But exactly how is this applied to Italic and Copperplate? Let's begin with Italic.

The standard line ruling for Italic allows equal space for ascenders, x-height, and descenders. If we add an extra space between lines, the effect on the texture of the writing is fairly dramatic.

This is standard interlinear spacing for Italic. It allows room for ascender, x-height and descender with no extra space between lines.

An additional five pen-width space between the descender and ascender spaces makes the texture of the page appear more open.

We can use this extra interlinear space in two ways: It can be left blank, which makes the writing look light and airy; or we can extend our ascenders and descenders, so they occupy some of this extra space. If we choose the second possibility, we may want to make the writing more decorative with flourished ascenders and descenders.

It is possible to use the extra interlinear space for the purpose of adding flourishes to some of your ascenders & descenders.

The more lines of writing on the page, the more effective this becomes.

For a more traditional approach to texture, that is, to make the page look more closely woven, you must decrease the interlinear space. This can be done by allowing less space for the ascenders and descenders, or by using a single, shared space for both the ascender and descender.

A

X

D

A

X

D

A

X

D

A
X
D + A
X
D + A
X
D

To write in shortened or shared ascender and descender spaces, you will have to simplify your letterforms, as shown in Chapter 7. This is fairly easy if the ascenders and descenders each have their own, albeit reduced, space, but more of a challenge when they share a space.

This is an example of the use of shorter ascender and descender spaces to make the page appear more textured than normally.

It is more difficult to do this when ascenders and descenders share a space. They may some-times collide with each other!

ITALIC: CHANGING THE WEIGHT

We experimented with heavy and light-weight letters in Chapter 9. These variations can be used with our new interlinear spacing to create other texture possibilities.

Using Guide Lines #12, in the spaces that are ruled for six pen-width Italic letters, write a few lines with no additional space between each descender and the ascender of the next line (standard line spacing) and then a few lines with an extra interlinear space.

Thinner letters create

a different type of texture.

This becomes even more

striking when there is

additional interlinear

space on the page.

To increase the texture, or to make the calligraphy appear denser, draw lines for a four pen-width x-height with shortened ascenders and descenders, so that the proportions are 3 : 4 : 3. Write several lines of text using these guide lines, and then try writing on lines with a shared ascender and descender space, also with a four pen-width x-height.

*Heavier weight letters with
short ascenders and descenders
increase the density of the text.*

*A shorter x-height combined with
shared ascender and descender
spaces can make Italic almost
as 'black' as Gothic calligraphy.*

USING PRINTED GUIDE LINES

Guide Lines #13 is ruled for a 2 mm nib, with all the spaces 2 mm apart. Make some copies of this page and darken the horizontal lines. That will enable you to experiment with various letter weights and interlinear spacing. Every space is equal to one pen width, which allows you to vary the interlinear space by very small increments. Follow the procedure outlined in Chapter 9 to try a variety of letter heights and weights.

Similarly, you can darken the horizontal lines to have shared ascender and descender spaces, with x-heights of your choice.

You can also use wider or narrower nibs in the same line spaces to increase or decrease the weight of the letters. Vary the nibs by ½ millimeter at a time to see what happens to the texture as the weight of the letters changes.

2 mm nib

The quick brown

1½ mm nib

fox jumps over

1 mm nib

the lazy dog.

2½ mm nib

The quick brown

3 mm nib

fox jumps over

COPPERPLATE: CHANGING THE INTERLINEAR SPACE

Copperplate calligraphy can also be used to create pattern and texture.

Increasing or decreasing the interlinear space, just as we did with Italic, can make a page of writing look less or more textured.

Compare a few lines of traditionally written Copperplate with lines with wider interlinear spacing. It is readily apparent that adding a little extra white space, sometimes as little as two or three millimeters between lines, makes the page look much more open and the writing appear to be lighter weight. And, like Italic, the addition of some extra flourishes to the white space also changes the texture of the page.

In this example, an additional two and a half millimeters between lines allows space for some bigger flourishes.

Reducing the interlinear space creates a closer texture. Use Guide Lines #14 to experiment with reduced interlinear space. See what happens when you write lines with ascenders and descenders that are the same length as the x-height, and what happens when the ascenders and descenders share a space.

Shortened ascender and descender spaces add texture to Copperplate because there is less white space in between lines of writing.

Just as with Italic, sharing the ascender and descender spaces gives a page of Copperplate quite a lot of texture, but can present a challenge to the calligrapher.

To avoid difficulties, when the ascenders and descenders share a space, shorten them slightly, so they don't touch the baseline of the line above the ascenders or the waistline of the line below the descenders.

Writing a long text with shared ascender and descender spaces can produce very tightly woven Copperplate, but there is the danger of collisions, when an ascender attempts to use a space already occupied by a descender. One way to avoid this is to write each line without finishing the descenders and then add them as you write the next line.

WIDE VS. CLOSE INTERLINEAR SPACE

Varying the interlinear space, as we have shown, can affect the visual texture of a piece of calligraphy, in both Italic or Copperplate. But what is the difference between wider and closer line spacing?

Wide Interlinear Spacing

1. gives your page of writing a classical, traditional, somewhat old-fashioned appearance

2. creates an open texture, with separate bands of black and white

3. allows you freedom to flourish or use the more decorative forms of ascenders and descenders

4. is easy to read

Close Interlinear Spacing

1. is a more unusual approach to Italic and Copperplate than wide spacing

2. creates more texture (i.e., a woven look to your writing, with ascenders and descenders that sometimes invade each others' space)

3. allows limited space for flourishing and usually works best with simpler letterforms

4. can be a little more difficult to read

In order to decide what kind of texture to create, you must consider these points of comparison, and ask yourself what you are trying to achieve. A traditional page of calligraphy? Something more modern? Something easy to read, or perhaps more challenging?

Remember that if your calligraphy is difficult to read, it may not be read! If your main purpose is to send a message or communicate something with your calligraphy, a more open texture may be preferable. But if you are designing a piece of artwork in which the shape and form of the writing creates an image that doesn't necessarily require legibility, then a more tightly woven or textured layout may be the best choice.

1. Look for a quote or poem of at least four lines which has as many ascenders and descenders
as possible. Try writing it two times in each Italic and Copperplate, first with a very open
texture and then with the lines of writing as close as possible. For the second version, do
your first draft in pencil, using guide lines with shared ascender and descender spaces. The
following is an example using Italic. The points of "collision" have been indicated between
the first and second lines.

Where are the songs of Spring? Ay, where are they?
Think not of them, thou hast thy music too~
While barred clouds bloom the soft dying day
And touch the stubble plains with rosy hue...

See where your ascenders and descenders bump into each other and try to adjust the
lines of writing to avoid these collisions. Use tracing paper to move some of the lines to the
left or right, thereby changing the position of the ascenders and descenders relative to each
other. You can also try changing the form of these strokes, by shortening them or curving
them slightly.

Once your pencil version is acceptable, try the text in ink. Remember to leave the
descenders of each line out and add them while writing the next line. This will help you
avoid letter collisions.

Where are the songs of Spring? Ay where are they?
Think not of them, thou hast thy music too~
While barred clouds bloom the soft dying day
And touch the stubble plains with rosy hue...

Where are the songs of Spring? Ay, where are they?
Think not of them, thou hast thy music too~
While barred clouds bloom the soft dying day
And touch the stubble plains with rosy hue...

2. Find a text that you like and decide what kind of texture best expresses the mood. Think about what an open texture (with or without flourishing) and what a closer, more woven texture suggests to you.

Write the text using the most appropriate interlinear spacing (in either Italic or Copperplate) and see if the result reflects the meaning of the text. Making this kind of judgment about form and content is a major step toward serious, thoughtfully designed calligraphic art.

Chapter 13

Color

Learning to use color is one of the most exciting parts of studying calligraphy and adds enormously to your artistic capabilities.

In this chapter, we will take a fairly fundamental approach to color, addressing some basic questions and explaining basic techniques. Please note that color can be a lifetime study and a single chapter can only scratch the surface. There are many very good books available about color theory and techniques, including some devoted exclusively to color for calligraphy.

WHAT MEDIA ARE RECOMMENDED?

Calligraphers write with paint. What does that mean? We write with pen and paint just as we do with pen and ink. The technique of filling the nibs with paint, however, is different from the dip-and-write technique we mostly use with ink.

The two kinds of paint generally used for calligraphy are *gouache*, sometimes called *designer color,* and *watercolor.* Gouache is a water-based paint, similar in texture to watercolor, the main difference being that watercolor is transparent and gouache is opaque. Both kinds of paint come in small tubes and are widely available. Watercolor can also be purchased in hard blocks or cakes.

Watercolor

Gouache

There are several reasons why gouache and watercolor are preferable to colored ink for calligraphy:

1. Gouache and watercolor are (mostly) permanent, where colored inks are fugitive (i.e., the color fades when the writing is exposed to direct light).

2. There is an almost infinite range of colors that can be created by mixing paint; your palette with ink is very limited.

3. Gouache and watercolor are water soluble. They can easily be washed off your nibs. Most colored inks are shellac- or lacquer-based; they corrode or otherwise damage nibs.

4. Gouache and watercolor can be diluted as necessary to produce fine hairlines. The lines made with colored inks are sometimes thick and gummy; a very fine line is difficult to achieve.

It should be noted that not every colored ink will damage your nib and not every paint color is permanent, but, by and large, gouache and watercolor are a much better choice for calligraphy than ink.

SOME ELEMENTARY COLOR THEORY

Color Wheel You are probably familiar with the color wheel, which is a simple visual reminder of how the six basic colors relate to each other.

The color wheel consists of three *primary colors*: red, yellow, and blue. *Secondary colors* are formed when you combine red and yellow (orange), blue and yellow (green), and red and blue (violet). Secondary and primary colors combine to make *tertiary colors*: red-orange, yellow-orange, yellow-green, blue-green, blue-violet, and red-violet.

The color wheel pictured here was painted using Winsor & Newton gouache. Be aware that colors with the same name can vary considerably from one manufacturer to another. While showing you the colors that are produced by mixing two or more other colors, printed color wheels won't necessarily show the exact colors you will create. (It is for this reason that we are showing a hand-painted color wheel, rather than a machine-made one which was colored with printers' inks.)

If you draw lines directly across the color wheel, connecting opposite colors, you have *complementary colors*: red and green, yellow and violet, blue and orange. We are taught in school that complementary colors should never be used together, but in fact the effect of two complementary colors in a piece of calligraphy can be very striking.

Warm & Cool Colors, Tints & Shades Certain colors are considered *warm* (red, yellow, and orange) and others *cool* (blue, green, and violet). The choice of warm or cool colors can enhance the effects of your calligraphy.

Colors can also be mixed with white to produce *tints*, or with black, to produce *shades*. There are many variations and gradations of warm and cool colors, tints, and shades.

Warm colors~
reds, yellows, oranges

Cool colors, such as

blues, greens, purples

Tints Red & White
Blue & White
Green & White

Shades Blue & black
Red & black
Green & black

Choosing Paint When purchasing paint, look for colors that are permanent. Fugitive colors should be avoided if you are intending to use your calligraphy for anything beyond exercise. Most brands of gouache and watercolor are labeled clearly to indicate whether the color is permanent, semi-permanent, or light sensitive (fugitive). This may be an alphabetic rating (A=permanent, B=semi-permanent, C=fugitive), or some other system, such as one star, two stars, etc.

Gouache and watercolor are not inexpensive, but a small tube will generally last a long time if it's used for calligraphy. (If you are using it for other purposes, such as coloring paper or painting landscapes, it won't last as long.) The price depends on the brand, but also on the pigment. Some reds, for example, are quite a bit more expensive than other reds, even though they are equally permanent.

There are many colors to choose from and a more expensive pigment may not be a better choice *for you* than a cheaper one. It is, however, a good idea to buy good quality paint, rather than student grade. Sometimes the cheapest brands are for children; if you don't know which are professional-quality paints, ask in an art supply store or check with the mail-order calligraphy suppliers.

It isn't necessary to buy many different colors in order to learn how to write with paint; just choose colors that you like or that may be appropriate for texts that you plan to write.

Other Materials You will also need a small watercolor brush, a number 1 or the equivalent, which will be used to dilute and mix the paint and to "feed" the paint to your nib. It is not necessary to buy an expensive brush.

A small plastic palette is useful, although an old ceramic dish or saucer can serve the same purpose. In addition, you'll need clean water containers and some new nibs. If your nibs have been used for ink, there's almost always some residue remaining on the nib which will pollute the color.

Storing the Paint Store the tubes of paint in an airtight container. Gouache, in particular, tends to dry out in the tube if it is left in a drawer or on your worktable. Take a few minutes to put your paint away whenever you aren't using it, either in a good quality plastic freezer container, a zipper-top plastic bag, or a combination of the two. If your paint dries in the tube, it can be reconstituted, but this is a tedious process. It is much easier to keep the paint soft by storing it carefully, rather than trying to soften it once it becomes rock hard.

Using the Paint If you are using paint from a tube, squeeze a small amount onto your palette or saucer. Add a few drops of clean water, either with your brush or from a small squeeze bottle, to one side of the paint and mix part of the paint with the water. The mixed paint should be thinner than the paint from the tube, about the consistency of ink. A drop of gum Arabic (a binder) added to your diluted gouache helps the paint adhere to the writing surface. If you are using watercolor in a block, add a few drops of water to it until the top of the block is soft and runny, just as you would if you were making a watercolor painting.

To add the paint to the nib, hold the pen in the hand you don't write with and, using your brush, fill the reservoir of your Italic nib or the underside of your Copperplate nib. (Don't ever dip the nib directly into the paint; this will clog the pen and prevent it from writing.) Tap the nib lightly against either the palette or a piece of paper so that the excess paint drips off, then make a stroke or two on your scratch sheet to be sure that the paint is flowing well. If the paint is too thin, it will drip out or make strokes that are too transparent; you'll need to add a little more paint to the watery paint on your palette. If the paint is too thick, your pen won't write at all; add a little more water to the paint.

Too thick

Too thin

Good consistency

Once the paint is flowing well, write the same way you do with ink. You will, however, need to rinse and refill your pen more often than is necessary when writing with ink, in order to keep the paint flowing well and the color and opacity consistent. This is especially important when working with gouache, which tends to dry rather quickly on the nib. Once this occurs, the pen won't work properly until it is cleaned and refilled.

You will also need to keep adjusting the consistency of the paint on your palette by adding water and mixing it with your brush. The additional pen washing and frequent adjustment of the paint consistency makes writing in color a slower process than working with ink, but the results are well worth it.

Mixing Colors Whether working with gouache or watercolor, the number of different colors at your fingertips is incalculable. Here are some guidelines for mixing colors.

When mixing two colors, squeeze a little of each color onto a separate part of your palette or mixing dish. Using a brush, add a very small amount of the lighter color to the darker color and mix well. If your color is still too dark, or not quite what you want, add a little more of the lighter color. Keep adding paint in very small quantities until the color looks right. Then, make a stroke or color swatch and allow it to dry before evaluating the color. Paint always dries a little lighter than it is when wet. If you aren't satisfied, add a little more of whichever color is needed.

The biggest mistake we make when mixing color is trying to change the tone too quickly. Undoing our mistakes can be more difficult (and can waste a lot more paint) than starting over.

Mixing colors that consist of more than two components is difficult. Patience is definitely an ally! Use your color wheel as a basic guide and adjust your colors using very small amounts of paint, just as you do when working with two colors. Allow your test swatches or strokes to dry before making further adjustments.

When experimenting with color mixing, it's a very good idea to make a note of component colors next to the swatch or sample. That way you will be able to make the same color again.

CHOOSING THE "RIGHT" COLOR

The word "right" is in quotes because it is subjective. There is no such thing as right and wrong in art and design. There may be better and worse choices, depending on who is making the artwork, what it is being used for, and who is looking at it.

Nevertheless, there are certain criteria we can apply when deciding about color for calligraphy. There is no doubt that color can affect mood, but even that is subjective and is, in addition, cultural. Colors that evoke certain reactions in one part of the world, for example, have entirely different connotations elsewhere. So the best we can offer are very general guidelines which reflect our own background and influences.

Choosing color(s) for calligraphy, like choosing letterforms, decoration and texture, is easier if we take time to think about what the words express or what mood we want our artwork to convey. These may not be identical; we can put a strong emphasis on a fairly neutral text by means of our design choices.

Brighter or more intense colors give a very different message from colors that are more subdued. Look at these four examples of the words For Sale:

For Sale

For Sale

For Sale

For Sale

The first two examples are more demanding and urgent than the third and fourth.

Similarly, tints (colors mixed with white) can be perceived in a number of ways, for example, friendly, casual, young, or maybe feminine. Darker tones or shades might be interpreted as more serious, masculine, or perhaps negative. Once again, please remember that none of this is absolute! You should always make your own decisions. And don't forget that the form, size, and weight of the script can also enhance the message.

Serious *casual* *casual*

Casual *serious* *serious*

Serious **Serious**

Casual

Warm and cool colors can also affect mood. See if you agree with the use of these colors for the words below:

Summer

Winter

Passion *Relax*

Cold Drink

Hot Soup

Combinations of colors are often more effective than single colors. Colors that are similar to each other (such as blue and blue-green) have a very different effect than complementary colors. The contrast of blue and orange, or red and green, in a piece of calligraphy can be shocking and draw the attention of the viewer more dramatically than a piece written in, say, yellow and orange. Complementary colors may not be the best choice for every piece of calligraphic art, but they do catch the eye of the viewer.

Does this word attract your attention ?

Does anything in this sentence catch your eye ?

Neutral colors, like browns and grays give a very different message than stronger, more decisive hues. The combination of a strong primary with a neutral color can also be used for the purpose of contrast.

COLOR ON COLOR

The examples shown thus far were all written on white or neutral backgrounds. But what happens when we use colored paper?

The effects of colored calligraphy on colored paper, like those of writing in two colors, can run the gamut from calm and gentle to wild and dramatic. Your capacity to create a particular mood increases when writing on colored paper.

The greater the contrast between the paint color and the color of the paper, the stronger the statement. Conversely, the closer in tone the paint is to the color of the paper, the less forceful the effect.

One interesting method for discovering the effects of color on color is to create a portfolio of color samples using different colored papers and several tubes of paint. Here is how to proceed:

1. Use a quarter or eighth of a sheet of charcoal paper in the following colors: bright red, yellow, blue, green, orange, and purple, plus two neutral tones, such as gray, ivory, or tan. The six bright colors should be close to the colors of the color wheel. (Charcoal paper is a good choice because it is easily available, inexpensive, and comes in a large number of colors.)

2. Squeeze red, yellow, and blue paint onto your palette. Either mix each of the secondary colors (orange, green, purple) or squeeze those colors from the tube. (It may be easier to buy the secondary colors than to mix them.) You should have six clean, separate colors. Fill two water containers for cleaning nibs and brushes; one for darker and one for lighter colors.

3. (Do this part very systematically.) Start with either a Copperplate nib or an Italic 2 or 2½ mm nib. Fill the nib with one color. Write a word or a letter or two on each piece of colored paper. Wash the nib thoroughly, fill the pen with another color and repeat. Do this until you have a sample written in Copperplate or Italic in each color on each paper. Then repeat this process using the other nib. Change your water whenever necessary to prevent the paint from being polluted by the colored water.

In the example shown, you will see that some colors (i.e., paint on colored paper) work well together, with very visible, vibrant results. Other colors, such as yellow paint on yellow paper, are almost invisible. Furthermore, the effects of Copperplate and Italic are different from each other.

Not every color is opaque and not every line is smooth. This will always depend on (a) the color you are writing with, (b) the paper you are writing on, and (c) the nib you are using.

4. To test tints and shades, you will need eight more pieces of the same colored paper. Add a very small amount of white to each of your colors and combine well. Make calligraphy samples with each nib on each piece of colored paper. Add a little more white and repeat. Do the same thing at least four times to see variations of the tints you can make with each color.

5. Do the same thing with shades. Start with fresh portions of each of your colors and add a tiny bit of black paint to each color. Make a sample of this shade on each piece of colored paper and then add more black in very small increments, writing a letter or a word on each paper with each pen until you have repeated the process at least four times.

This is a long process, no doubt about it. But once you finish it, you will have an excellent resource for making color choices.

Look at the color samples you have made. You now have six different pure colors written with each nib on each piece of colored paper, plus four tints and four shades for each of the six paint colors. Do some of them send a clear message as to mood or emotion? Are some more demanding than others? More disturbing? Serious? Frivolous?

By spreading out your sample sheets, you can easily see the effects of many color-on-color possibilities. When you are deciding what colors to use for a piece of calligraphy, you can refer to this color portfolio to help you make a good choice.

HOMEWORK

1. Let's see what happens when we use color for maximum and minimum contrast.

 Choose a short text, either a quote of 15 to 25 words or a few lines of poetry, which includes a line or a few words that you wish to emphasize by means of color contrast.

 Using either Copperplate or Italic, write the text in each of the following ways to express *maximum* contrast:

 a. Using neutral colored paper, write the text in a primary color with the contrasting words or lines in its complementary color.

 b. Using a sheet of brightly colored paper, write the text in either a complementary color (such as green paint on red paper or violet paint on yellow paper) or any other color that "jumps off" the page. Look at the color samples you prepared to see which combinations are most compelling.

 c. Write the main body of the text in a soft, low intensity color (such as a tint or a neutral shade) and use an intense primary or secondary color for contrast.

 For *minimum* contrast, try the following possibilities:

a. Write your text in a color that is as close as possible to the color of the paper, such as red on red, blue on blue, etc.

b. Do the same but let the paint be slightly different from the paper color.

c. Write your text in two or more similar colors, changing color very slightly every time you fill your pen.

2. Use color to express emotion. Choose a text that you find particularly evocative, for example: very sad, romantic, funny, or angry.

Decide what color best expresses this emotion or mood. Look at your color samples to see if that effect may be intensified by using the color on colored paper or in combination with another color. Consider whether the text would be more effective in Copperplate or Italic.

Based on these decisions, write your text. Once you have written it, look at it and ask yourself some additional questions. Should the calligraphy be larger or smaller? Is the background color a good choice? Can I emphasize the mood with more color? More contrast?

This is only the beginning. Once we start to use color in calligraphy, it's hard to go back to ink!

In the next two chapters we'll discuss how you can use basic layout and design techniques, combined with strong letterforms and good color choices to produce many forms of calligraphic art.

Chapter 14

Layout & Design ~ Your Own Choice of Text

Many calligraphy students imagine that effective layout and design demands a level of expertise that is difficult to attain. Let's start by eliminating that idea completely; if you have come this far, and have done some of the Homework assigned in this book. You already know a lot about design; in fact you are already doing it!

The process of laying out artwork, calligraphic or otherwise, is simply a matter of deciding what goes where on the page. Well, maybe "simply" is a bit of an exaggeration, but there are some straightforward steps you can take to create a successful layout.

(*Note:* The suggestions and guidelines presented in the following pages are equally applicable to Italic and Copperplate calligraphy. Which hand to choose generally depends on the content or the purpose of the words you are writing.)

We'll begin by determining *what* we want to write before figuring out *how.*

CHOOSING A TEXT

There are innumerable possibilities to choose from. We are sometimes assigned a text to write, such as a poem, quote, invitation, or a formal document, such as an award or a diploma. If someone else (a friend, client, or family member) requests or commissions a job for us to do, we must use the text as it is presented. We'll discuss this in the next chapter.

But if you are choosing your own text, perhaps for an exhibition piece or a publication, or, in this case, to learn about layout, here's a suggestion: choose something you care about. Sounds

obvious? Well, it should be, but all too often we grab the first thing we see, just to get started. Don't do that. Take the time to select a poem, quote, prose text, or some song lyrics that mean something to you. It can be a few lines that you love or maybe something that someone you know cares about.

The reason we emphasize the importance of making a good selection is that you will be "living with" this text for a while. It is relatively rare to sit down and write out the words once and have the calligraphy and layout come out exactly right. On the contrary, a successful calligraphic piece generally requires several drafts; it takes thinking, sketching, writing, and rewriting. So choose something you won't mind looking at again and again.

The other reason to choose a text carefully is that in order for your calligraphy to be expressive, to contain some feeling or mood, *you must feel something for the words you are writing*. Your feelings don't need to be profound or intensely dramatic, but you should react in some way to the words; a text that's funny, romantic, or political can evoke reactions just as well as one that's sad or philosophical.

If the text has been chosen by someone else and you feel nothing, just do your best.

HOW TO BEGIN

It's always good to start by *thinking*—it's sometimes easier to think with a pencil in your hand. Look at your text and ask yourself some questions.

1. What is the mood of the text? Happy? Sad? Serious? Intellectual? Romantic? Lyrical? Businesslike? Funny? Spiritual?

2. What word or words are the most significant? There is usually something that should be emphasized. Perhaps it's the first word, the first two or three words, the first line, or perhaps some important words that appear in the text. It may be just the first letter of the text or, if it's a poem, the first letter of each line. Underline, or otherwise indicate, the most important word or words.

3. What style of calligraphy best expresses the text? Given the limitations of this book, Italic and Copperplate, you can choose one of those hands and then decide if the writing should be simple or flourished, large or small.

BASIC LAYOUT CHOICES

At this point, you have selected your text, decided which style and size of calligraphy to use, and what words you want to emphasize. For the purposes of the instructions that follow, let's assume that your text is comprised of four to six lines of poetry or prose.

The traditional page layout options are: symmetrical, flush left, flush right, or asymmetrical but balanced along a central axis.

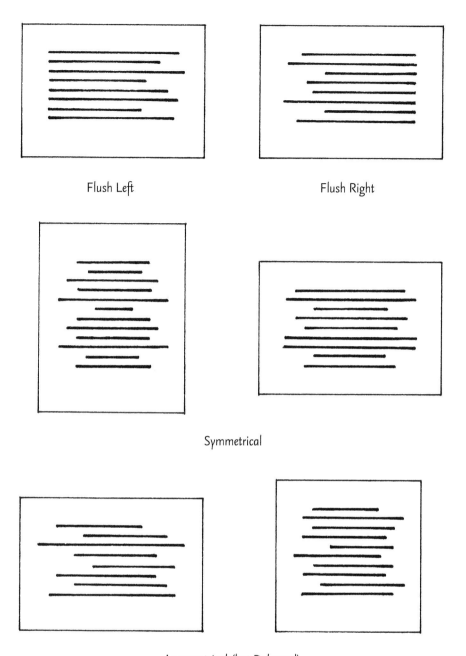

Flush Left

Flush Right

Symmetrical

Asymmetrical (but Balanced)

The paper can be vertical, horizontal, or square, but often this decision is based on the actual "shape" of the writing, i.e., the length and number of the lines. It's a good idea, when possible, to choose the outer dimensions of the paper, and whether it is horizontal, vertical, or square, after you have made some other decisions.

In this illustration, layouts A and B are clearly better choices than C and D.

Space Between Lines Your lines of writing can be close together or far apart. Review Chapter 12 for rules and exercises in creating texture. This decision can be based on page size (i.e., the actual limitations of the paper), or, preferably, on the feeling you want to express.

Space Around the Writing Almost without exception, *more is better*. Try to allow as much space as possible around your text. You can always cut the paper later, but it is pretty hard to add extra space to a sheet of paper that is too small.

Contrast Think about how you want to emphasize important words or phrases. Contrast can be created through *size, color, weight*, or *calligraphic style.**

*Using Italic as a contrast to Copperplate on a piece of calligraphy isn't usually recommended because of certain stylistic similarities that make them unsatisfactory when used together. If you can write other styles of calligraphy, such as Gothic and Roman, try them as a contrast to either Italic or Copperplate.

Size contrast is always an effective layout choice. This works equally well in Italic or Copperplate. Try variations in size as well as position of the words to see what works best for you.

The use of color for the purpose of contrast is also a good idea. Experiment with various color combinations as well as trying color with black. There are endless possibilities and the art~work can be very striking.

Don't forget that **weight** can also be a good way to show contrast. This is somewhat easier to achieve when writing **Italic** than it is in **Copperplate**.

With larger calligraphy, differences **in weight** are even **more** visible !

An important rule is: Contrast must be sufficiently visible in order to be effective. A slight contrast of size, weight, etc., looks like a mistake rather than an intentional choice.

There is not quite enough
contrast of color in this
example to be effective.

Words that are only slightly
different in size or weight
may look like mistakes.

Color What color(s) are appropriate for this text? Should the calligraphy be in color? On colored paper? Making decisions about color is interesting, complicated, and opens a world of artistic possibilities.

HOW TO PROCEED

First Draft Start with a pencil and make some sketches. Used ruled paper or practice paper and appropriate guide lines. Write out your text carefully, to get an idea how it might look with a simple flush left layout. Does it fit on the page horizontally? Would it look better vertically? Are the lines too long? Too short?

Tracing Paper Use some tracing paper and change the flush left layout to a flush right one. Also try tracing the lines along a center axis. To do this, measure and mark the center of each line. Draw a center line on a piece of tracing paper and lay the tracing paper over your pencil sketch, moving the tracing paper back and forth as you trace each line, matching the center mark on the pencil sketch with the center line on the tracing paper.

Why so pale and wan, fond lover?

Prythee, why so pale?

Will, if looking well can't move her,

Looking ill prevail?

Prythee, why so pale?

Why so pale and wan, fond lover?

Prythee, why so pale?

Will, if looking well can't move her,

Looking ill prevail?

Prythee, why so pale?

Contrasting Words Look for ways to create contrast. Write out the important words on a separate piece of paper in larger or heavier calligraphy than the rest of the text. Sometimes writing these words in all capitals is effective, though this works better in Italic than Copperplate. Cut these words out and place them over your pencil sketch to see how they look. If you decide to emphasize a single letter or several letters, rather than words or phrases, write those letters separately and cut them out as well.

Make several additional pencil sketches, trying to find a good direction for your text. Remember, it's easier and quicker to write repeatedly in pencil (and erase as necessary) than with pen and ink.

Why so pale and wan, fond lover?
Prythee, why so pale?
Will, if looking well can't move her,
Looking ill prevail?
Prythee, why so pale?

Why so pale and wan, fond lover?
Prythee, why so pale?
Will, if looking well can't move her,
Looking ill prevail?
Prythee, why so pale?

Why so pale and wan, fond lover?
Prythee, why so pale?
Will, if looking well can't move her,
Looking ill prevail?
Prythee, why so pale?

Pen and Ink Draft Once you have chosen your layout, write your text in ink, still working on practice paper, following the general form of your pencil layout. Write the words or letters you wish to use as a contrast on a separate piece of paper, also in ink. Cut them out and lay them over your pen and ink draft. Try different contrast possibilities to see which work best: bigger, smaller, all capitals, etc.

Note that changing the size of some of the words will change the width of the lines and sometimes the interlinear space as well.

Why so pale and wan, fond lover?
Prythee, why so pale?
Will, if looking well can't move her,
Looking ill prevail?
Prythee, why so pale?

why so pale ?

Why so pale

why so pale ?

'Why so pale

Why so pale

Why so pale and wan, fond lover?
Prythee, why so pale?
Will, if looking well can't move her,
Looking ill prevail?
Prythee, why so pale?

Why so pale and wan, fond lover?
Prythee, why so pale?
Will, if looking well can't move her,
Looking ill prevail?
Prythee, why so pale?

Cut Your Work Into Strips Now cut your lines of writing into strips and place them over a sheet of white paper. You might want to tape two sheets of practice paper together to give yourself a large enough field.

See what happens when you move the lines closer together, further apart, to the left or right. Change your contrast pieces (the words or letters you have written and cut out separately) to see which are preferable. You can also cut your strips apart, making one line into two, or some lines longer and others shorter.

Title & Author If your text has a title or credit line (author, book title, date), write them separately too, trying some variations in size or style. Cut out these strips and see where they look best relative to the text.

Titles are usually positioned at the top, in calligraphy that is the same as, or more prominent than, the rest of the text. Credit lines, which may include an attribution (from *title of book*, by *author*), generally go at the bottom and tend to be smaller or lighter weight than the calligraphy of the text. These lines may be centered if the text is centered; if the text is flush left or right, look for the best position for the title and/or credits, by moving them around until they look right.

Encouragements to a Lover ÷ Sir John Suckling

Encouragements to a Lover
Sir John Suckling

Encouragements to a Lover
Sir John Suckling

Once you have your text positioned (including lines of writing, contrasting words or letters, title and/or credits), tape it to your white background paper, using removable transparent tape.

Margin Space Consider the space around the text. Your artwork should be visually balanced left and right, top and bottom. This means that the white space to the left and right of the writing should be approximately equal. The space at the top is also about the same as the space to the left and right, and the space at the bottom is slightly larger.

There should be enough white space around the writing so that the page doesn't look crowded. It's difficult to assign a mathematical proportion to the relationship between text area and margin size. A standard measurement would allow about 2″ of white space around a piece of writing that measures less than 5″ or 6″ in width or height; if the artwork area is larger, allow 3″ or more around it. These measurements are not going to work for every design, but they are a good starting point.

The best way to make decisions about margin size is visually. Using four strips of cardboard, position a frame around your text that you can move in and out to see how much white space should be left around the writing. You can also do this with two L-shaped pieces of cardboard.

Now it's time to take a break. Walk away from your layout and come back later or tomorrow.

MAKING FINISHED ART

Before beginning the final (or semi-final, or semi-semi-final) draft, take another look at your layout. Are you satisfied? Is it positioned well on the page? You can move your cardboard strips up or down, in or out, to change the balance between positive and negative space (i.e., between the artwork and the space around it).

You can also remove your tape and move the lines, changing the distance between them. You can change the length of the lines, by cutting them into smaller pieces or adding part of one line to the end or beginning of another line.

At some point you'll need to stop reworking your layout and make a commitment! (Don't let yourself become anxious; you can always do the text again. In fact, calligraphers almost always *do* change the text again!)

Paper You don't want to use practice paper for "finished" calligraphic artwork. But what paper should you write on? This is a question that every calligrapher faces sooner or later and sometimes quite frequently.

Writing on "good" paper is a pleasure for the hand and the eye. But selecting the correct paper for the work you are doing isn't always easy. Papers of various qualities, textures, colors, and prices are sold both in pads and by the sheet. Paper by the sheet is often available in larger or better stocked art supply stores.

There are many, many choices, especially when purchasing paper by the sheet. Paper can be machine made or handmade; it can consist of various materials, both natural (such as cotton fiber) and artificial. Some papers will deteriorate or discolor over time. To avoid this, look for paper that is acid-free or archival. A good art shop will have that information available. Some colored papers, like some paints, are light-proof; others will fade in direct light. That is an important factor to consider when choosing paper.

Paper surfaces are often protected with a coating called *sizing*. Sizing prevents the ink or paint from being absorbed by the paper. If paper is not sized, such as some rice papers, ink will be absorbed, much the way a paper towel absorbs water. Too much sizing results in a slick or slippery surface, which is also difficult to write on.

Most of your questions can be answered by the paper supplier, but there is a lot you can determine on your own. The best advice we can give you is to *test your paper*. How do you do this? Simply by writing on it. A practical approach to learning about paper involves creating a *paper file*.

Making a Paper File To make a paper file, start by collecting samples (small strips or cuttings) of different papers, such as drawing paper, charcoal paper, and watercolor paper. Carefully label each sample with the name of the paper, the size of the full sheet, and, if possible, the place you bought it and the price. This will enable you to get the same paper again, if and when you need it.

Write a letter or a word on each paper sample, in Italic and Copperplate. It's a good idea to write large and small, and also to try various inks and paints. Even a small writing sample will give you the information you need about the paper: Does the pen move smoothly along the surface or does it catch in the paper fibers? Does the paper absorb the ink? Is it too slippery? Does the paper work better with ink or paint? Is one kind of ink better than another? You will see immediately that some papers are preferable for Italic, others for Copperplate.

Name of Paper, Size, Place Purchased, Price

Name of Paper, Size, Place Purchased, Price

Name of Paper, Size, Place Purchased, Price

Name of Paper, Size, Place Purchased, Price

Name of Paper, Size, Place Purchased, Price

Name of Paper, Size, Place Purchased, Price

Name of Paper, Size, Place Purchased, Price

Save these samples in a file folder or somewhere easily accessible. Then, when you are ready to do a piece of calligraphic artwork, you can choose the paper best suited to the size, style, and medium you wish to use.

One final suggestion for learning about paper is to swap or share ideas and paper samples with other calligraphers. There are far too many papers for anyone, especially a relatively inexperienced calligrapher, to sample without an enormous cash outlay. Ask for suggestions and recommendations from other calligraphers and calligraphy teachers. Although paper choice is a matter of taste, some advice can help avoid frustrating and/or expensive mistakes.

Drawing Lines & Writing the Text Choose a piece of better quality paper that is at least the size of your layout, including the margins. Unless the good paper is quite transparent, which is rarely the case, you will need to draw lines in pencil.

Measure your taped layout very carefully to determine:

1. the x-height, ascender, and descender sizes

2. the spaces between lines

3. the distance from the top of the paper to the first baseline

4. the distance from the left edge to each writing line

5. the measurements (ascenders, x-height, descenders) for the letters or words that you intend to write bigger or differently from the rest of the text

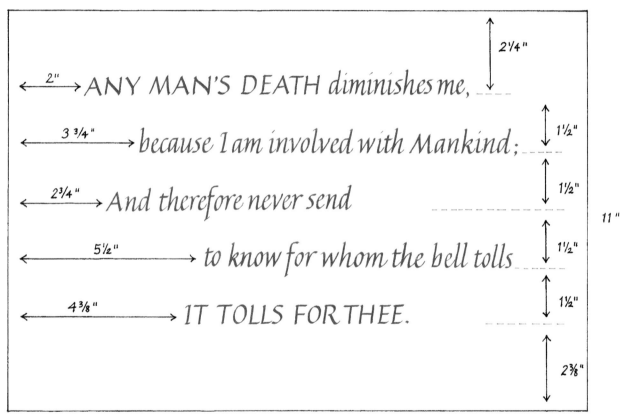

Make notations on your layout of all of these measurements and then rule lines on your good paper, carefully following the measurements on the layout. Use a well-sharpened 2H or 3H pencil, pressing lightly, so your lines will be thin. They must be easy to see, but not impossible to erase.

If you are planning to write in Copperplate, draw slant lines as well. It's always a temptation to leave the slant lines out because it's extra work to draw them. But it is definitely worth the effort. If the slant of your Copperplate letters varies, it can spoil an otherwise good piece of calligraphy.

Once your lines are drawn, go ahead and write your text. The way to make this a little less stressful is to use your layout as a guard sheet. Put it under your hand, positioned so that each line of the layout is directly below the space where you are about to write. This is very easy if you fold each line on the layout after completing the finished calligraphy so that the next layout line becomes the top line of your guard sheet.

Don't be discouraged if the finished piece isn't exactly the same as the layout. Lines of writing frequently come out a little longer or shorter, depending on how accurately the guide lines are drawn and also how tense or relaxed you may be.

Dissatisfied with the results? Try it again. But before you do so, look at the finished piece and think about how it can be improved. If the layout is good but the calligraphy could be better, rule the same lines and try again. If the layout isn't quite right, decide what you wish to change. Sometimes it's just a question of moving the title to the left or right, or perhaps changing the size or position of one or two lines. Or perhaps the first letter is too big or too small. See if you can make these changes on your taped layout before ruling any new lines, so that when you start your next draft you'll be confident about what you are doing.

The finished piece (or pieces) of artwork often surprise us. Sometimes, even when the results aren't quite what we intended, they are pleasing or at least interesting. And they almost always give us an idea for the next piece of artwork.

A Note About Color

You have probably noticed that very little has been mentioned about incorporating color in your layout, apart from a passing word about color being one choice for creating contrast.

Color, as we have previously discussed, can enhance your layout and add an additional level of meaning to your text. Making the right choices can add dimension and strength to your calligraphic artwork.

Layout & Design ~ Commercial Calligraphy OR Getting the Job Done

During the early stages of our calligraphic education, we concentrate on the fundamentals: pen angle for Italic, pen pressure for Copperplate, and learning to make well-formed, consistent letters. A little later on, spacing and rhythm become equally essential.

But once these elements are more or less in place (i.e., once you can write without checking every stroke against an alphabet exemplar) it is time to use your calligraphy for pleasure and occasionally for profit.

Calligraphic art can be roughly divided into two categories: work we do for ourselves and work we do for others. The biggest difference between the two is that we choose the words we write for ourselves; when we do calligraphy for someone else, whether a client or a friend, the text is not of our own choosing.

In Chapter 14, we discussed layout and design for our personal artwork (non-commercial work) and how important it is to choose a text carefully. If the words we are writing have been chosen or assigned by someone else, the design process can be both easier and more difficult. It is easier because a promise, or better still, a deadline, is a big motivator for starting and finishing a project, but it is harder because we are generally required to work within certain defined parameters (size, color, etc.) and often must satisfy someone else's taste.

We're going to call this kind of work *commercial calligraphy*, whether it's been commissioned by a corporation, assigned by a teacher, or requested by a relative. How much, and indeed *if* you get paid to do the work is not a factor in defining commercial calligraphy. Your level of skill

and professional attitude should not depend on how much you are being paid. This is important because calligraphy is sometimes poorly paid, considering the level of expertise and artistic ability, to say nothing of time, required to get the job done. But this is a separate, albeit important issue.

Getting the job done in a satisfactory and timely manner is a necessity for the working calligrapher. Here are a few suggestions for those of you who want to get involved in the commercial calligraphy world.

SET UP A SPACE

It is not necessary to rent a studio or renovate your basement, but having a space dedicated to calligraphy is a big advantage. A room used exclusively for artwork is a wonderful thing to have, but not everyone has that luxury, especially those who are relative newcomers to calligraphy.

What you do need is a desk or table where you can set up and leave your art materials, preferably where they (and you) will not be disturbed. It is much harder to concentrate on calligraphy, whether your own work or commercial work, if you have to pack and unpack your pens, inks, paints, and paper every time you want to work.

Working in a quiet place, without unnecessary interruptions, increases both concentration and efficiency. Space dedicated to calligraphy, away from the television or the center of your family activity, will help make this possible.

And of course you also need good light.

GET THE FACTS

Whatever the assignment may be, you want to do it accurately, without any unnecessary mistakes. You may want to redo a job because you aren't satisfied with how it turns out, but you should never have to do it over because you made an incorrect assumption about the client's requirements.

It is therefore necessary to ask some questions:

1. When is the job needed? Getting a firm deadline is important. If your client says, "I don't know, whenever you have the time," he or she should realize that you may never get around to it! Even if the deadline is three months away, try to make a firm commitment.

2. What is the *exact* text? If your client is vague, you may make an incorrect guess, and then be asked to redo the job, at your own expense. Get the text in writing (typography, not handwriting) before you begin. E-mail is okay, but a phone message is not.

 If you have doubts about spelling or grammar, ask the client. Even if you think it's obvious, don't make these decisions yourself. It's much easier to make a phone call or send an e-mail before you begin the job than to redo it because your client "wanted it that way."

3. What style(s) of calligraphy does the client have in mind? He/she may have no ideas, in which case you may want to send some samples or make suggestions. The choice of calligraphic style is something you and your client should agree about in advance.

4. Is the job in color or black and white? Does the client have color preferences? Sometimes the difference in price between calligraphy written in black ink and in color (paint) may help the client make a decision.

5. How much decoration (flourishing, border design, drawing, etc.) is needed or desired? Be wise; don't offer services you can't perform.

6. Is there a size requirement? Some jobs, such as invitations, need to fit a certain format. Other jobs, like writing out texts to be framed, may need to fit on someone's wall or be inserted into an album or a book. Sometimes people want something written large or small for their own reasons. All of this needs to be discussed.

7. How much is the job paying? This can be complicated and/or sensitive, and may require negotiation. This question should be discussed *before* you begin. You may not be charging anything at all or you may have an established price list. But be sure to be clear about it, no matter whom you are working for. It can be very awkward to discuss this once the work is completed.

 If you are charging for your work and your price is higher than your client is prepared to pay, it's much better for all concerned to discuss this in advance. You may be able to convince the client that the price is right. Or you may be able to modify the requirements of the job in order to charge less, or decide that the project isn't for you. Sometimes saying "no" is a very good option.

COMMERCIAL JOBS

Among the typical assignments that calligraphers receive, apart from writing out prose or poetry, are place cards, invitations, menus, awards and other citations, and occasionally, posters or flyers.*

When writing out a text, the steps described in the previous chapters should be helpful, but it is advisable to consider the questions enumerated earlier in this chapter before you begin. Writing a calligraphic text for yourself is similar to doing it as a job, but satisfying a client means being sure of what he or she has in mind.

Other kinds of calligraphy jobs are more straightforward. In many cases, the main skill required, once style, size, and color have been agreed upon, is centering.

Centering Centering a name or a line of writing is fairly easy, but if you don't do it properly, you can waste a lot of time and paper. This skill is generally required for writing names on place cards or escort envelopes, as well as for fill-in work, such as putting names on diplomas or pre-printed awards and certificates.

Centering is considerably easier if your writing and spacing are consistent. In any case, before you accept any professional work, your calligraphy should be good enough that a word or name comes out the same size and width each time you write it. Small variations are normal, but if the

* You may have noticed that we are not including envelopes. Addressing envelopes is often the first job or project beginners undertake. Most introductory calligraphy classes and many beginner books explain how to do this.

same name written with the same pen is 2″ wide the first time and 3″ wide the second time, you need more practice!

One of the ways to center a word or a line is to write it twice. Start by writing it out carefully on a piece of practice paper using the same pen and the same size guide lines that you will use for the finished work. If you are centering a short list of names, write out all the names, one beneath the other, on your practice paper.

Measure each line carefully and write the measurements next to the words. Mark the center of each line. You can do this with a centering ruler, if that makes dividing fractions easier.

John Barrymore 2½″

Anabel Lee 1¾″

Charles Dickens 2⅜″

Mary Shelley 2⅛″

Ryoko Otaki 2″

Thomas Alva Edison 3¼″

The next step is easier if you use a light box.*

On your light box, tape guide lines that are ruled for the place card or award you are inscribing. Draw a center line on your guide lines with measurements to the left and right of the center line. If a name is 2″ wide, for example, it will start 1″ to the left and end 1″ to the right of the center.

* A light box is a structure that is similar to what dentists use to look at X-rays. It consists of one or two fluorescent bulbs covered by a sheet of glass or acrylic glass. Tape your guide lines to the glass and turn on the light, which is either behind the glass or inside the box. A sheet of paper, an envelope, or even a place card can be positioned over the guide lines, and the lines will show through the paper. This saves a lot of line-drawing time.

For each card or award, match the measurements on your practice paper with the numbers on your guide lines, in order to begin the name (or line of writing) in the correct place.

Shortcuts If you are writing out more than a few names, you may want to speed this process up. Here are a few suggestions:

1. Be sure the list is typed flush left. Most of the time, names that are the same width typed will be close to the same width *as each other* when written calligraphically. This is not an absolute; m's and w's are wider than i's and j's, and if there are three names (first, middle, and last name) with three capital letters, that are the same width as two names (first and last name) with two capitals, the calligraphic version may be wider. Capitals, especially Copperplate capitals, are wider relative to lower-case letters than typographic capitals.

 Nevertheless, if you write out the first dozen or so names, plus any that are unusually long or short, and measure them, you should be able to make a good guess as to the measurement of many of the other names on the list.

2. If you have good computer skills, you can save time by centering your list and formatting it in a typeface that is similar in size and style to your calligraphy. With practice, this will help you estimate the calligraphic width of the names on your list, especially if you also write out a few names and measure them.

INVITATIONS

A formal invitation is most often centered, but not always. It is a good idea to discuss this with your client, and an even better idea to show a few samples so the client can choose the style of calligraphy, the layout, and the amount (if any) of decoration. If you have never done any invitations, make a few samples—centered and flush left, Italic and Copperplate—to show your potential clients. Preparing these samples in advance will give you the experience and the confidence to offer this service when someone asks for it.

If you are designing a centered invitation, the lines will be positioned under each other in a symmetrical format. Write out each of the lines of the text, one under the other, using guide lines that allow the standard interlinear space (i.e., ascender, x-height, descender, ascender, x-height, descender) with no additional space between lines. Measure the lines and mark the center of each line, much as you would if you were centering names for place cards.

You are cordially invited
to attend a reception
to celebrate the marriage of
Katherine of Aragon
&
King Henry the Eighth
Saturday, June 12
at five o'clock
Palace Hotel, London

Draw a center line in pencil on a piece of tracing paper. Trace the lines of calligraphy in pencil, centering each line, without changing the interlinear space, to see how the invitation looks. You can then decide if you want to leave an extra space between lines or perhaps separate one or more lines with an additional space.

Standard Interlinear Spacing

Additional Interlinear Spacing

Additional Space for Names

You may decide to write a capital letter or one or more words larger, such as the names of the bride and groom or the guest-of-honor, the first letter of the invitation, or the name of the occasion being celebrated. Do this in ink on your practice paper and trace it in pencil on your tracing paper layout. Using tracing paper enables you to make several different, fairly quick layouts in order to compare them and decide which is the best.

If you wish to use an ornament of some sort on the invitation, such as a flourished letter or a calligraphic decoration, add that to your tracing paper layout as well.

Once you are satisfied with the design of the invitation, draw guide lines very carefully, indicating the width of each line and the interlinear space of your layout. Put these guide lines on your light box and write out the invitation in ink on a piece of practice paper to see if it really looks the way you think it will. (The tracing paper pencil layout sometimes looks a bit different from the pen-and-ink version.)

Make any additional adjustments to your pen-and-ink draft before starting the final version. It's not too late to move things around or replace a letter with a variation or to add an ornament or flourished capital. Once you make the finished version, however, changes in layout are more difficult to make.

If the invitation is flush left, the process is similar but quicker. The entire text should be visually centered on the page, even though the lines of text are not symmetrical. This involves writing the text and then adjusting the left and right margins so that it appears to be centered.

Visually Centered Unbalanced

In either case, centered or flush left, be sure that there is enough space to the left and right, top and bottom, so that the appearance of the invitation is graceful and balanced.

If the invitation is to be printed, you can work larger than the final printed size and have the printer reduce your artwork to fit the card size, which is usually a standard measurement. In fact, it's a very good idea to confirm the size possibilities, with both your printer and your client, before you design the invitation.

Caroline Paget Leake

Mr. and Mrs. Richard Alan Stevens
request the honour of your presence
at the marriage of their daughter

Rebecca Adelaide
to
Mr. Raphael Carland

son of
Mr. and Mrs. John Michael Carland

Saturday, the twenty second day of September
two thousand and seven
at two o'clock

Saint Mary's Church
942 Hopmeadow Street
Simsbury, Connecticut

The favour of a reply is requested by
the first day of September

M _____

__ will attend with pleasure __ must decline with regret

Entrée choice:
__ tenderloin of beef __ salmon __ vegetarian

Reception to follow
at five o'clock.

The Hill-Stead Museum
35 Mountain Road
Farmington, Connecticut

Reply card enclosed

Anna Pinto

Please join us
as we celebrate
this special day in our lives
when our daughter

Emily Michelle

is called to the Torah
as a Bat Mitzvah
on Saturday
the eleventh of December
two thousand four
at nine forty five
in the morning
Temple Ner Tamid
Bloomfield, New Jersey
Kiddush luncheon
immediately following services

Amy and Scott Claman

Sheila Richter

Celebrate our Marriage
on Saturday, the Fifth of October
at seven o'clock

Dinner and Dancing
Penthouse Suite
The Stanhope
Fifth Avenue at Eighty-First Street
New York, New York

Cynthia Harmon and Ira Levinson

R.s.v.p. *Black Tie*

Carole Maurer

MENUS

Like invitations, most menus are either centered or flush left, and may be written out one at a time or printed from a single original. This generally depends on the use of the menu; menus for restaurants or large parties are printed; for a small party, calligraphers sometimes make a single menu or hand-letter a few.

An important difference between menus and invitations is that invitations are often written in a single size and style; menus frequently require two or three kinds of writing (e.g., large, medium, and small, or lightweight and heavyweight) to differentiate between main headings and subtext.

Once again, we recommend that you start with practice paper and tracing paper. Whether the final menus are centered or flush left, printed or original, follow these steps to make the job easier for yourself:

1. Look at the text of the menu. Annotate it as to which parts are the most important, which are of secondary importance, and which are the least. This is usually easy: the name of the restaurant or the event is the most important, the rest can be divided into either food (larger)

and wine (smaller) or the names of food categories (appetizers, main courses, etc.) and the dishes being served. If you aren't sure, check with the client.

Marguerite's Diner *- Most Important*

Sunday Brunch *- 2nd*

12 noon – 5 pm *- 3rd*

Appetizers *- 2nd*

Soup du Jour
Vietnamese Spring Rolls } *3rd*
Fruit Salad

Main Courses *- 2nd*

Mushroom Omelette
Brioche French Toast
Eggs Benedict } *3rd*
Salade Nicoise

Desserts *- 2nd*

Chocolate Mousse
Apple Crisp } *3rd*
Strawberry Tart

2. Decide how to differentiate between the important words and those that are less important. The key here is *contrast*. To make part of the design more prominent, it is necessary to create contrast of size, form, weight, or color. If the menu is being written or printed in more than one color, this can be a simple and effective way to divide the text. If only one color is used, then obviously you'll need to find another way to create contrast.

3. Once you have made these decisions, proceed as you would when designing an invitation. Write the words in appropriate sizes or weights on your practice paper and then use tracing paper to arrange the lines of writing—centered, flush left, or whatever format you prefer. You can leave extra interlinear space as necessary to separate categories or menu items; an equally spaced menu may be harder to navigate than one where the interlinear spacing helps divide the text logically.

Marguerite's Diner

Sunday Brunch

Appetizers

Main Courses

Desserts

12 noon ~ 5 pm
Soup du Jour
Vietnamese Spring Rolls
Fruit Salad

Mushroom Omelette
Brioche French Toast
Eggs Benedict
Salade Niçoise

Chocolate Mousse
Strawberry Tart
Apple Crisp

4. Try various possibilities on tracing paper, and when you are satisfied with your layout, draw guide lines and make a draft of the menu using ink or paint. Consider the position on the page and the space around it. If you are making individual menus and working in color, or using color for the purpose of contrast, mix your paint and test it to see if the colors work well before starting the final artwork.

Marguerite's Diner

Sunday Brunch
12 noon ~ 5 pm

Appetizers
Soup du Jour
Vietnamese Spring Rolls
Fruit Salad

Main Courses
Mushroom Omelette
Brioche French Toast
Eggs Benedict
Salade Niçoise

Desserts
Chocolate Mousse
Apple Crisp
Strawberry Tart

5. If you are making individual menus, as opposed to preparing artwork for printing, choose heavy enough paper so that they won't be easily damaged. (Remember that menus are often handled by people who may not realize that they are artwork.) They can be protected by having them laminated or you can spray finished menus with an acrylic or waterproof spray to keep the paint or ink from smearing.

6. If your menus are to be printed, prepare them by cleaning up or retouching the calligraphy, and whiting out extraneous marks. Indicate the dimensions of the paper with crop marks or a non-repro blue pencil outline. Spray the artwork to protect it from careless handling and cover it with tracing paper. Write any notes to the printer on the tracing paper, including specific information about colors and the kind of paper that the work will be printed on. Ask your printer for paper and color samples and also for details of his requirements.

· DESSERTS ·

Chocolate Triangles
Raspberry Dream Bars
Apple Coconut Haystacks
Pâte de Fruit
Hazelnut Biscotti
Bourbon Pecan Cookies
Pignoli Almond Cookies
·
Catskill Mountain Organic Coffee
Numi Teas

Anna Pinto

THE MUSEUM OF MODERN ART
WEDNESDAY·OCTOBER 10·2001

Alberto Giacometti

MENU

Artichoke with Shrimp in Tarragon Sauce
Céleri Rémoulade

Beef Bourguignon
Mashed Potatoes with Caramelized Onions
Haricots Verts

Hot Apple Charlotte
Nutmeg Ice Cream

Coffee

MARSANNAY BLANC VIEILLES VIGNES 1998·BOUVIER
JULIENAS GRAND RESERVE 1997·GRANGER

Barry Morentz

JULY 17
1999

*Cavaillon Melon with Lobster
and Crabmeat
Gin Mayonnaise*

*Grilled Quail
Sauteed Baby Artichokes and Mushrooms
Risotto Timbale
Pear and Turnip Purée*

*Wedding Cake
Dessert Buffet
Coffee*

CHABLIS 1er CRU "VAILLON" 1995 (DEFAIX)
CHAMBOLLE MUSIGNY 1er CRU "CHARMES" 1994 (BARTHOD)
MOSCATO D'ASTI 1998 (DEFORVILLE)

Barry Morentz

❦

LA CARTE
Diner du 15 Janvier 1993

White Bean Soup with Pancetta and Arugula

Salad of Mâche and Endive with Walnut Vinaigrette

CHOICE OF:
Seared Salmon with Crème Fraîche and Caviar
OR
Grilled Noisettes of Veal · Merlot Jus
OR
Sliced Grilled Breast of Chicken
Citrus Ginger Emulsion

Roasted Red Bliss Potatoes

Fresh Asparagus

Chocolate Ambrosia Fantasy

❦

Barry Morentz

Clear Soup. custard garnish
Barley Cream Soup

Red Mullet, Italian sauce
Lamb's Sweetbread in Cases

Green Peas, French style
Fried Potatoes
Roast Chicken, watercress garnish

Celery and Pimiento Salad

Vanilla Soufflé
Strawberry Open Tart
Savoury · Sardine Croustades

Cheese

Carole Maurer

Like menus, these may be one-of-a-kind or printed. As previously mentioned, it is necessary to get all the information before you begin, including the order of importance of the text: which words are most important on the poster, what is secondary, and what is least important. Find out the exact dimensions of the poster, if it's being printed, or discuss the size with your client if you are making a single original.

Since posters and flyers are somewhat more complicated than invitations and menus, you would do well to make a few pencil sketches (called *rough sketches* or *roughs*) to get some basic layout ideas.

Posters and signs generally require some large writing; we therefore suggest that you choose Italic rather than Copperplate for this project. Copperplate is a very good option for most other commercial jobs, but it is quite difficult to write large-scale Copperplate. It can be done, but Italic lends itself much more easily to oversized writing (as do other broad-pen alphabets, but this book concerns itself only with Italic and Copperplate).

Rough Sketches Make several calligraphically drawn sketches approximately one-quarter the size of the finished poster. To do this, draw outlines on graph paper. If your poster is 8½" x 11", for example, your outlines will be 4¼" x 5½". If the poster is 12" x 18", one-quarter size is 6" x 9". Make your sketches in pencil, starting by positioning the most important words. Make these words big, even though you may choose to enhance the contrast by means of color or weight as well as size.

Write the secondary text in pencil using smaller calligraphy, and then the least important words in an even smaller size. You can also consider writing part of the text in capitals. Use your eraser freely and make several sketches until you have a layout you like.

It is sometimes easier and quicker to work one-eighth scale, rather than one quarter, especially when making preliminary sketches. If you draw a number of outlines on graph paper that measure 2⅛" x 2¾" (for an 8½" x 11" poster), you can make some quick sketches that will help you decide which layouts work and which will not.

One-Quarter Scale Sketches in Pen and Ink This step is not always necessary, but it can help you clarify your ideas. Make a pen-and-ink version of the layout, also in one-quarter size, using the appropriate width Italic nibs for the height and weight of the letters in your pencil sketch. This will help determine if the words will fit on the poster or if you need to write bigger or smaller. Make some notes about what colors you want to use.

Additional Information, etc.

BOOK SALE

One Day Only!

Full-Scale Calligraphy Write out all of your text full size on strips of practice paper. Use nibs that are two times the size of the nibs you used for your one-quarter scale model. Draw guide lines carefully on the practice paper for these lines of writing. If you write the biggest words in your layout with a 4 mm nib, you will need to write the same words with an 8 mm nib. If the small writing was done with a 2 mm nib, you'll need a 4 mm nib for the full-scale writing.

For nibs larger than 5 mm, use poster pens. These are available in one millimeter increments from 6 mm to 15 mm, and can be purchased from calligraphy mail-order dealers. With practice, these nibs are very nice to use for poster writing. (It's a good idea to spend some time learning to use oversized writing tools by doing some calligraphy on practice paper, just to get used to the feel of the pen and the flow of the ink or paint.) You will probably find that a standard 5 mm nib is big enough for most posters and flyers.

Once you have written all the lines of the text on strips of paper, lay the strips on a white background that is the size of the poster or flyer. Position the strips according to your layout and see if they fit properly and the lines of writing relate to each other effectively.

Tape the layout in place and look at it from a little distance. Is the message clear? Are the lines too close together, too far apart? Should there be more white space somewhere? Should any part of the writing be bigger? Smaller? Heavier? All capitals? Now is the time to make any changes. Rewrite any unsatisfactory part of the layout and replace the strips with lines that work better.

Finished Art Before doing the finished artwork, make some color samples. If you are making a single poster, rather than having it printed, test your colors against the background of the poster, especially if you plan to use a colored poster board. Decide which colors to use based on the effects you wish to achieve or the message you want to relate (*see Chapter 13*).

Measure your layout carefully and write the measurements directly on your layout: x-heights, distance between lines, distance from top, bottom, and sides, etc. Use these measurements to make guide lines, either on a guide sheet for your light box (if your poster is small enough or your light box is large enough) or on a piece of poster board. Don't forget to make slant lines as well as horizontal lines. It is definitely worth the extra time to do so; if the slant varies it will be very noticeable.

Write the words with the largest pen first, then the second largest, then all the rest. You don't need to write the words in pencil on the poster as long as your guide lines are carefully drawn. It might be a good idea, however, to remove the strips from your layout one at a time and hold them under the line you are writing in order to match the spacing and width of the words. This can also give you extra confidence, especially when writing unusually large.

Allow the artwork to dry completely before erasing guide lines, if you are using poster board. You can retouch your Italic letters with a Copperplate nib or a very fine-point, waterproof marker.

Alice Koeth. Posters reproduced courtesy of Pierpont Morgan Library, New York. Original size 21¼″ x 24½″.

Alice Koeth. Posters reproduced courtesy of Pierpont Morgan Library, New York. Original size 21¼″ x 24½″.

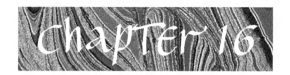

To Continue

Nowadays, thanks to the wonders of technology, the concept of the isolated calligrapher, cut off from sources of information and communication, is becoming increasingly rare. Although calligraphy does occasionally attract loners, the age of the calligraphy community is definitely upon us.

There are many ways to reach out to other calligraphers and continue your education once you've closed this book. If you have actually completed all the Homework and design projects suggested in these pages, you are probably full of new ideas of your own. Calligraphy is like eating potato chips; once you start, it's hard to stop!

CONTINUING EDUCATION

There are many routes, formal and informal, to further calligraphic education. Many calligraphy guilds and associations offer workshops and, occasionally, more extensive classes (i.e., weekly classes or one- or two-week intensive classes) for intermediate and advanced students. There are also master classes that require a portfolio or some amount of prior training for admission.

More often than not, these advanced classes and workshops are offered through calligraphy organizations rather than colleges or adult education programs (which are a good source for introductory classes). Getting involved with, or getting mailings from a calligraphy organization is a good idea. These associations, which have flourished worldwide during the past couple of decades, welcome members at any skill level and are grateful to volunteers. Helping out is a good way to meet other calligraphers and find out what's happening in the calligraphy world. Meetings and newsletters will keep you up-to-date on classes and workshops as well as exhibitions and lectures. Ask your calligraphy friends or teachers for contact information, or search on the Internet.

If classes or workshops are offered in your area, don't hesitate to explore new avenues of calligraphic education. Calligraphy classes tend to be small and teachers are usually very pleased to work with intermediate students. Good skills in Italic and Copperplate are an excellent foundation for further study.

INDIVIDUAL RESEARCH

There has been a large increase in calligraphic book publication in recent years. Although book-stores often limit their calligraphy selections to a few books, Internet book dealers have just about every calligraphy book in print, and many that are out of print. The mail-order calligraphy dealers have wonderful book lists and offer descriptions of the content and level of the books they sell. Be sure to send for catalogs or look them up on line.

In addition to numerous how-to books, there are many featuring the work of contemporary calligraphic artists as well as historical examples. You will also find reproductions, facsimile books, of many beautiful manuscript books, such as the illuminated books of the Middle Ages and the writing books of the Renaissance and the eighteenth century, often beautifully printed and presented. Although these books can be quite expensive, you can sometimes find them (and other calligraphy books) in second-hand bookstores, thrift shops, library sales, and flea markets, often for very low prices.

Libraries are also a good source of calligraphy materials, although you will probably have more success with libraries that specialize in manuscripts or art books, rather than local branch libraries. A few libraries have calligraphy collections, as do some museums. Although these collections are sometimes available only by special appointment, calligraphy guilds often organize visits which include a curator or specialist who arranges for you to see particular books or rare manuscripts. There are a few—though not yet enough—museums dedicated to calligraphy. Your local calligraphy guild should be able to give you information about these resources.

EXHIBITIONS

Take advantage of calligraphy and lettering exhibitions. Sometimes these are shows of new or relatively new artwork, and sometimes they consist of historical calligraphy, such as early engraved books (Copperplate) or medieval manuscripts. Seeing calligraphy "in the flesh," as it were, is quite different from looking at reproductions in a book or on a computer screen.

Sometimes, especially if you are member of a calligraphy guild, there are opportunities to exhibit your own calligraphy. This is the perfect time to design and *finish* a piece of calligraphic art. Even if your work is rejected (which happens to everyone at one time or another), completing a piece of calligraphy is an education in itself and an achievement not to be discounted. Often the motivation of an exhibition, like that of a deadline, propels us to finish artwork we might otherwise delay or abandon. And when your work is accepted and displayed, it's wonderfully satisfying to see it on the wall.

I am the secretary at the Church of the Holy Trinity
on East 88th Street,
and on the day of the recent blizzard I was helping with
preparations for a party that evening...
I was also worried that fewer people would come
because of the snow.

I stepped out on the porch of the parish house to take a breather
and delight in the snow-covered dogwood and magnolia.
Three very bundled well-into-middle-age women
came up the walkway. One was in a wheelchair.
They went onto a pathway that even on good days is difficult.
Why, I wondered, were they pushing a wheelchair
on this path in this weather?

I got my answer when, on the count of three,
two of the women helped the one in the wheelchair up
and plopped her on the snow-covered lawn.
She sat upright for a couple of seconds, then lay down
and started to make a snow angel, flapping her "wings."
After much giggling,
the other two helped her back into her chair.
Then they plopped onto the lawn and made their angels.
More giggling. Lots of it.

The snow kept falling.
The people came to the party.
All was right on East 88th Street.

by Erlinda Brent, in The New York Times' Metropolitan Diary · 7 Feb 05 · ✢

All the best for 2006 from Anna Pinto & Pieter Sommen

Anna Pinto

Thinking of you

TO

Donald R·Griffin

with warmth and appreciation for your
contributions to the field of Animal Behavior
and with gratitude for your friendship,
encouragement and critical insights, over the years.
June 25, Nineteen Eighty-seven

Jeanyee Wong

*The roots of happiness
grow deepest in the soil of service*

WILLIAM ARTHUR WARD

*Letters are symbols
which turn matter into spirit*

ALPHONSE DE LAMARTINE

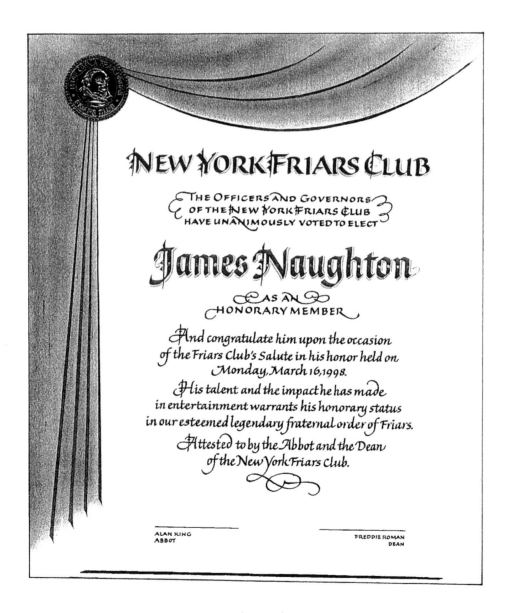

NEW YORK FRIARS CLUB

THE OFFICERS AND GOVERNORS
OF THE NEW YORK FRIARS CLUB
HAVE UNANIMOUSLY VOTED TO ELECT

James Naughton

AS AN
HONORARY MEMBER

And congratulate him upon the occasion
of the Friars Club's Salute in his honor held on
Monday, March 16, 1998.

His talent and the impact he has made
in entertainment warrants his honorary status
in our esteemed legendary fraternal order of Friars.

Attested to by the Abbot and the Dean
of the New York Friars Club.

ALAN KING
ABBOT

FREDDIE ROMAN
DEAN

Alice Koeth

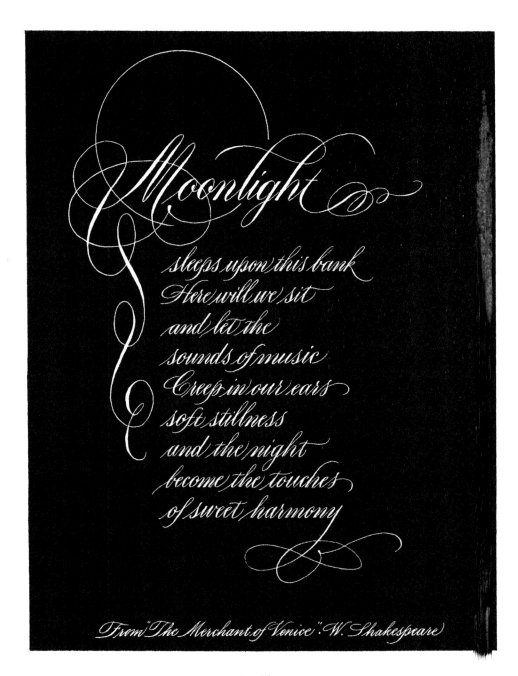

Pat Blair

Nature's first green's gold
her Hardest hue to hold.
Her early leaf's a flower
But only so an hour.
then leaf subsides Leaf.
So Eden sank to grief
dawn goes down today.
Nothing gold can stay.

Pat Blair

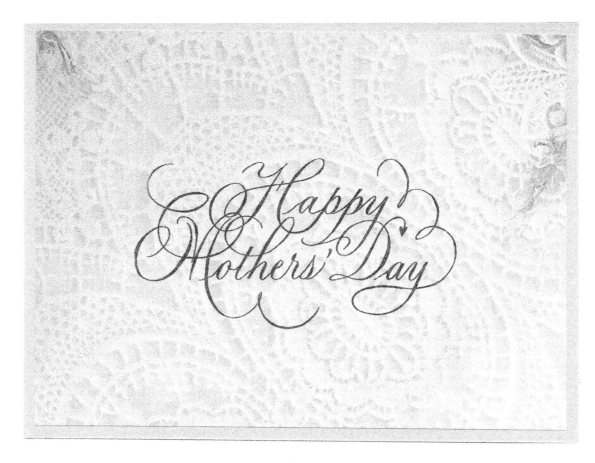

Carole Maurer

APPENDIX

Guide Lines

1. Italic, Brause 3 mm, 5:5:5

2. Copperplate, 3:2:3

4. Italic, Brause 1 mm, 5:5:5

Italic, Brause ¾ mm, 5:5:5

5. Italic, Brause 4 mm, 5:5:5

6. Italic, Brause 5 mm, 5:5:5

7. Copperplate, 3:2:3

8. Copperplate, 3:2:3

12. Italic, Brause 3 mm, 6:6:6

13. Italic, Rule It Yourself

14. Copperplate, Rule It Yourself